PICTURE

PERFECT

FOOD

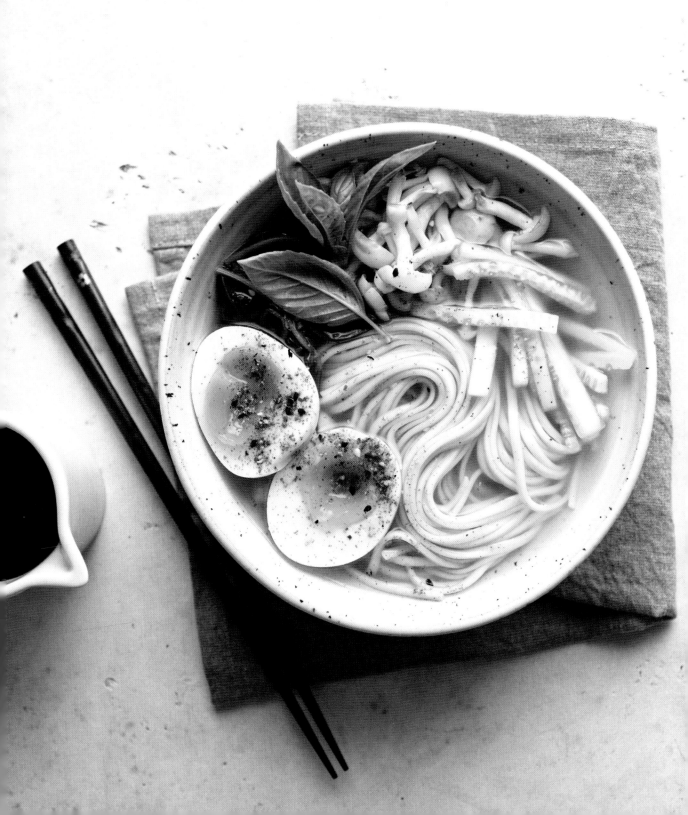

MASTER THE ART OF FOOD PHOTOGRAPHY
WITH 52 BITE-SIZED TUTORIALS

PICTURE
PERFECT
FOOD

JOANIE SIMON

Creator of The Bite Shot

PAGE STREET
PUBLISHING CO.

First published in 2021 by

Page Street Publishing Co.

27 Congress Street, Suite 105

Salem, MA 01970

www.pagestreetpublishing.com

Distributed by Macmillan, sales in Canada by The Canadian Manda Group.

25 24 23 22 21 1 2 3 4 5

ISBN-13: 978-1-64567-255-5

ISBN-10: 1-64567-255-7

Library of Congress Control Number: 2020944187

Cover and book design by Meg Baskis for Page Street Publishing Co.

Photography by Joanie Simon

Printed and bound in China

TO THE VIEWERS ON YOUTUBE: YOU ARE THE BEST AUDIENCE EVER. THIS BOOK WOULD NOT EXIST WITHOUT YOUR SUPPORT.

+ **TABLE OF** CONTENTS

COMPOSITION 71

Arranging the Elements within the Frame for Maximum Visual Impact

FOOD STYLING 103

Making Your Food Photo-Ready

FINDING INSPIRATION 137

Continuing the Journey and Encouraging Your Creativity

✚ INTRODUCTION

My husband, Ryan, and I moved from our hometown of Phoenix, Arizona, to New York City in the summer of 2007. Three weeks after our wedding, we were in a moving truck crossing the George Washington Bridge filled with nervous excitement about the big, wild adventures ahead. We settled into new jobs, a new neighborhood, made new friends and, most importantly, discovered new food.

Ryan worked in a foundry, and I was working at a school. We weren't making much money, but the money we had went toward culinary experiences. We explored the local restaurants and markets, taking suggestions from friends on the best places to eat. We ate our way across the city, accumulating new favorites like the gargantuan chocolate chip cookies at the bakery around the corner from our apartment, the savory lapsang souchong-infused scones from the little breakfast joint on 86th Street and the piping hot soup dumplings on Pell Street in Chinatown.

Around that same time, I started to cook more adventurously in our tiny apartment. I had a kitchen full of cookware gifted to us from our wedding and was inspired by the variety of ingredients at the local markets. Between dining out and cooking at home, New York City inspired me, and I wanted to share it with everyone back home. So, I set up a blog, bought a pink point-and-shoot camera and posted on my website photos of what I was cooking and eating. That first food blog was the start of what would eventually become my career in food photography.

For the record, those early photos were terrible. But I had the one thing that I believe you need in order to create great food images: a love of food. I also had something that I'm sure you have, too. I had a vision in my mind's eye for how the photos should look. I wanted the food to jump off the page, to convey that the dish was delicious. It took years of hard work for those visions in my mind to be present in the images coming out of my camera. So, as you take steps on your own photography journey, be patient with yourself and your work. The things most worth doing won't come easily. Food photography is more than lining up your camera in front of a dish of food and hitting the shutter button. It's a myriad of creative decisions coming together to create an effective image.

The good news is that your journey can move quicker than mine. The pages of this book are filled with the important lessons that moved my skills forward during that difficult period between falling in love with food photography and feeling confident behind the camera. I will lead you through 52 lessons and challenges, one for each week of the year. These chapters will deepen your understanding of camera settings, lighting, storytelling, composition, food styling, props styling and finding inspiration through applied learning. After all, experience is the best teacher. I recommend having a notebook and a pencil handy for reflection and note-taking to cement your learning. I frequently use a notebook to plan my shoots, so this will become a helpful tool beyond the exercises in this book. The activities here are suited for any kind of camera, from phone cameras and point-and-shoot to DSLR and mirrorless cameras. No matter the camera you have, take the time to learn it inside and out.

Many of the lessons also include images I captured for this book. Feel free to re-create these images, especially if food photography is new for you. I tried on the styles of other photographers until my work evolved into what felt like an aesthetic that was uniquely mine. Experimentation helps you uncover your own authentic voice and perspective. And as you work through the activities, share your work online and use #pictureperfectfood to connect with your fellow readers on social media.

Whether you're capturing food for the pure enjoyment of the experience, you're working hard to launch a food product into the marketplace or you want to get more eyeballs attracted to your food blog, food photography is a fun and fulfilling craft. I am thrilled to have the opportunity to be your teacher and wholeheartedly believe in your ability to master these skills.

Want to enjoy more food photography education? Join my Insider List at joaniesimon.ck.page/picture-perfect

+ SOME NOTES ON PHOTOGRAPHY GEAR

The most frequently asked questions I receive are in regard to gear. Cameras, lights, accessories, phone vs. DSLR vs. mirrorless, etc. The blessing and curse of our modern photography era is that we have an unbelievable and ever-expanding number of options when it comes to gear. The good news is that you can't make a wrong decision. **The best option is always to start with what you have.** Once you have a firm grasp and command over your existing tools, then you can invest in additional gear based on your needs.

But most importantly, if you don't take anything else away from this book, I want you to know that a "better" camera will not give you better photos. It's like asking a baker which brand of oven they use to make their impossibly flaky, buttery pie crust. The oven is far less important compared to the skills of the baker. The real magic in any craft is the result of combining creative instincts with thoughtful practice. Save your money and invest your time in learning instead.

+ My first camera!

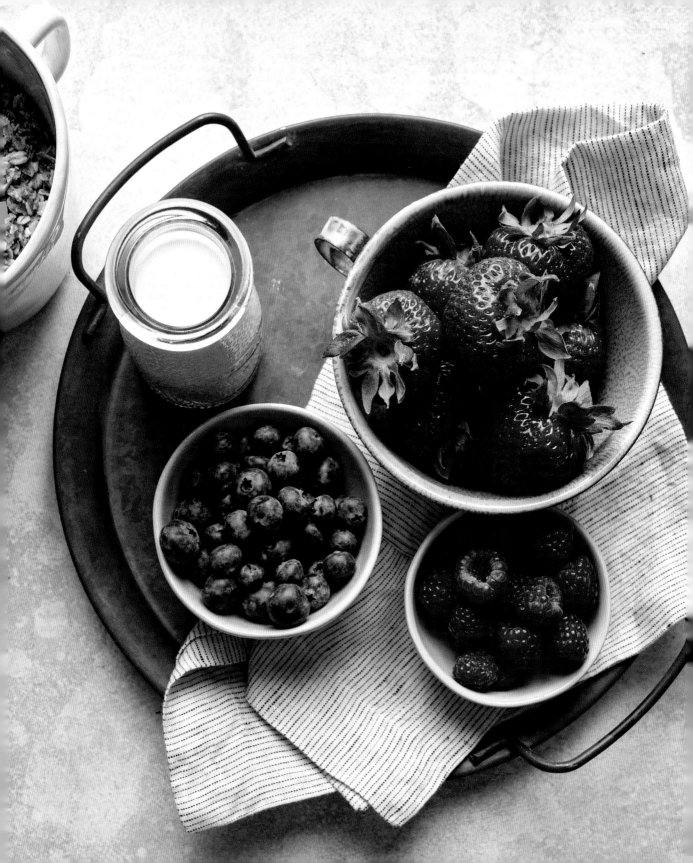

CAMERA SETTINGS

Turning Numbers on a Dial into Creative Techniques

+

Cameras are powerful. They enable us to share the visions in our heads with the press of a button. F-stops and shutters do more than simply expose an image. The creative applications for camera settings are endless. Let's start our photographic journey with understanding and applying the essential camera settings, then explore how they can be used with artistic intention. These will be the most technically complex concepts in the book, so if you can wrap your mind around these lessons, you'll have an excellent foundation on which to build your photography skills.

1. TAKING CONTROL
OF THE CAMERA

This is where it all starts. You introduce light and shadow to a subject and press a button to capture an exposure that is rendered on your LCD screen as an image. Per definition, in digital photography, the exposure is the amount of light that reaches the camera's sensor to record the image. I imagine the light particles traveling through the lens, into the camera, burning themselves onto the surface of the sensor inside and recording all the details of what was light and what was shadow down to the last detail. **The brightness or darkness of that exposure is based on the combination of three camera settings: aperture, shutter speed and ISO. You'll hear this referred to as the exposure triangle.**

The other lessons in this chapter dive deeper into these three key settings and creative ways you can use them to add interest to your image. But to start, it's important to know that each of these settings can be manipulated to make an exposure brighter or darker.

OPENING AND CLOSING THE APERTURE OF THE LENS

First, **aperture refers to the opening inside the lens that allows light to enter the camera**. The aperture can be opened up wide to let more light into the camera, giving you a brighter exposure, or made to be smaller to create a darker exposure. **The aperture's size is measured in f-stops, and the smaller the f-number, the wider the aperture opening**. For example, if you see that a camera's aperture is set to f/2.8, that's a small number and a rather wide opening compared to f/7 or f/9, which would be smaller apertures. Sound backward? Yes, it feels backward that a smaller number gives you a bigger opening. Welcome to photography.

Ultimately, if you want a brighter exposure by allowing more light into the camera, adjust the aperture setting to a smaller number. If you are in a darker room at f/7.1 and want to make an image brighter, you can adjust to a wider aperture like f/4.5, or depending on your lens, all the way down to f/1.8. If you're shooting outside and the exposure is too bright and overexposed, then move to a higher f-number for a smaller aperture opening, like f/7 or higher. Later on, we'll dive into the trade-off of these choices, but for now, I want you focused on exposure.

SELECTING A FAST OR SLOW SHUTTER SPEED

The second setting is shutter speed. When you hit the shutter button on your camera to take a picture, you'll hear a "click" sound. Even on phones, though they don't have the same mechanical parts as a traditional camera, they replicate this sound as it's a cue to capturing an exposure. That "click" is the camera's shutter opening and closing. The shutter is located inside the camera in front of the sensor. **When the shutter is open, the light coming through the lens is able to reach the sensor and record the picture.**

+ PHONE SHOOTER TIP

Many smartphone apps, such as Adobe Lightroom for mobile, have a shooting mode that allows you to opt into the "Pro" mode where you can manipulate shutter speed (read as "Sec") and ISO. Aperture on phone cameras and some point-and-shoot cameras is generally fixed and cannot be manipulated, but don't let that stop you from fully exploring the control you do have over your exposure.

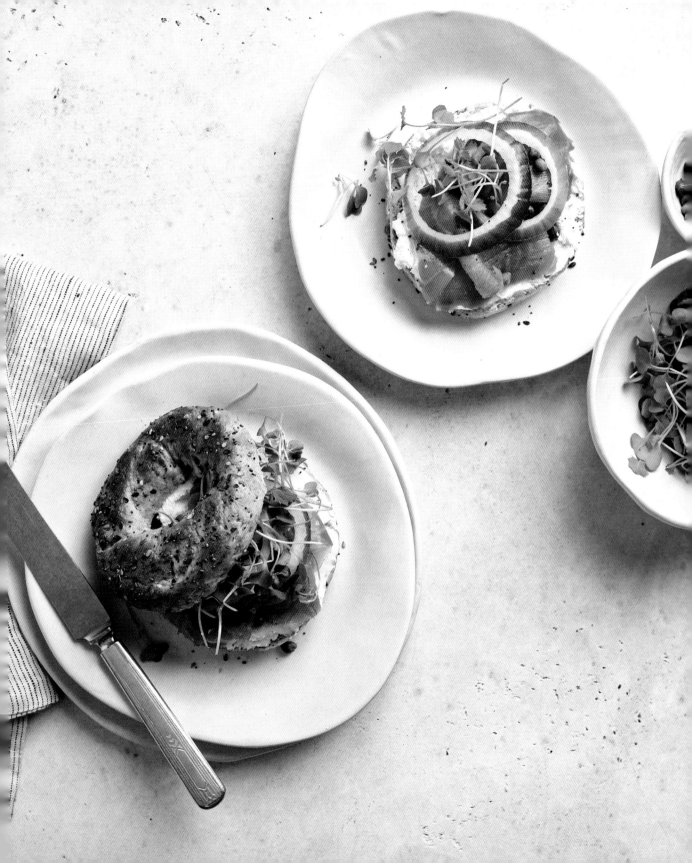

The moment you press the shutter button, the shutter is opened, the sensor is exposed, the shutter then closes and the image is recorded. This process can happen quickly or slowly depending on the shutter speed you select.

If you select a relatively fast shutter speed, like 1/200th of a second, the window of time when the shutter is open and light is coming in is rather short, which means it's not letting in much light. But if you shoot with a slower shutter speed, it will allow more light to hit the sensor because the shutter is open for a longer period of time. That slower shutter speed will create a brighter overall exposure in comparison. Shutter speed is represented on the camera settings as a measurement of time in relation to a second. For example, 1/200 is one two-hundredth of a second, 1/1000 is one-thousandth of a second and 1" is one full second. (The quotation sign indicates a full second.) One second is a long exposure and will let a lot of light into the camera.

ADJUSTING THE SENSOR'S LIGHT SENSITIVITY WITH ISO

Finally, the third setting is ISO. ISO is a measure of how sensitive the sensor is to light. When you hit the shutter button and the light travels through the lens and through the shutter to the sensor, how receptive is that sensor to the light hitting it? I think of ISO like flypaper. Do you want the sensor to be super sticky to catch every last little bit of light it can, or do you want it to be a little less sticky? A lower ISO number, like 100 or 200, is less sensitive compared to higher settings like 1,000 all the way up to your camera's max ISO. The higher the ISO, the brighter your exposure will be.

As a recap, **to create a brighter exposure, utilize a wider aperture, a slower shutter speed or a higher ISO. To create a darker exposure, use a smaller aperture (higher f-number), a faster shutter speed or a lower ISO**. But the question remains, how do you know which aperture, shutter speed and ISO are the right ones to select in a given situation? Each of these settings controls the exposure, but they also have their own unique advantages, disadvantages and creative applications. The following lessons dive deeper into each of these settings, guiding you further in your decision-making regarding camera settings. But for now, the most important thing to understand is that these three settings in combination with one another dictate the brightness or darkness of our exposure.

+ CHALLENGE

Put your camera in Manual mode. If you've never done that before, it's time to move out of auto and claim total control!

Next, find out where you can change the aperture, shutter speed and ISO and start to manipulate these settings.

Dial in the following camera settings (or something close to them depending on your camera): Shutter Speed = 1/100, Aperture = f/5.6, ISO = 100. Then take a test shot of any subject. Don't try to make the image beautiful or perfect; we're simply working on exposure for now.

Now, evaluate that test shot and decide if it's too dark or too bright. If you need to brighten it up, you can select a wider aperture, a slower shutter speed or a higher ISO. If it's too bright, make it darker with a smaller aperture, a faster shutter speed or a lower ISO. Adjust your settings until you feel you have a properly exposed image.

Continue to practice this exercise in order to become more comfortable with changing the settings and their impact on exposure. This might feel difficult and require a lot of thought at first, but I promise, the more you practice operating your camera settings manually, the more natural it will become and the more command you will have over your images.

2. CHOOSING THE RIGHT DEPTH OF FIELD
FOR YOUR SCENE

Remember when I said that aperture not only controls the amount of light entering the camera based on the size of the opening inside the lens, but it also has creative applications? Have you ever noticed in some images that the subject is in sharp focus while the area in the background is blurry? **That blurry factor, called bokeh, is related to the aperture.** The aperture controls the depth of field. Depth of field describes the area of focus within the image. A wide depth of field means that a lot of the area in the image is in focus from the front of the scene to the back. A narrow depth of field, on the other hand, means that there is a small area within the image that is in focus, and everything in front of and behind that small area is blurry, creating bokeh.

- When you select a wider aperture (a smaller f-number), it produces a smaller depth of field and creates bokeh.

- When you select a smaller aperture (a higher f-number), it produces a wider depth of field so more of the image is in focus throughout.

You can see this principle in play in the images on the next page. The one with the blurry bokeh background was shot at f/3.5. The one that's more in focus throughout was shot at f/7.1. Neither is right or wrong, better or worse. Like many choices in food photography, it's a matter of personal taste.

+ PRO TIP

The closer you are to the subject, the more pronounced the depth of field will be. If you shoot at f/2.8 close up to the subject, and then f/2.8 farther away from the subject, the one captured physically closer to the subject will create even more of that beautiful blurriness in the background.

+ PHONE SHOOTER TIP

Unfortunately, the lenses in our phones don't have a native ability to manipulate aperture yet. I say "yet" because technology is rapidly changing. However, portrait mode is a setting that replicates the look of bokeh by detecting the primary subject in your scene and then adding a mask around it that blurs the background. It's not always perfect and sometimes blurs out things it shouldn't. But it will achieve the same effect of isolating your subject to help simplify the composition and add dimension.

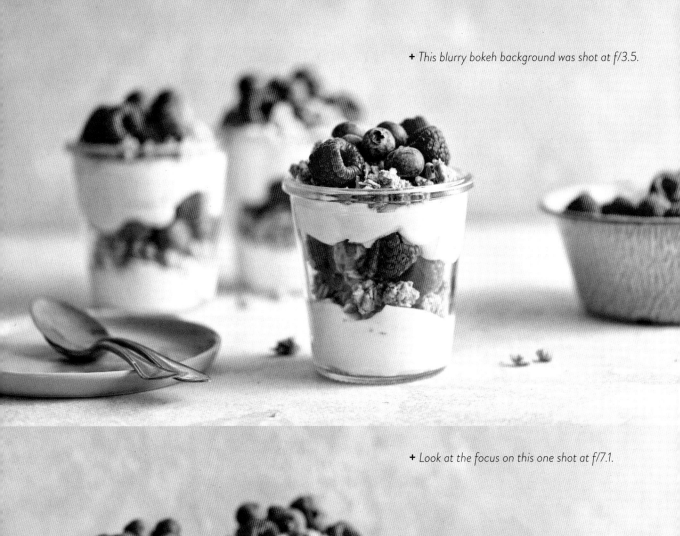

+ *This blurry bokeh background was shot at f/3.5.*

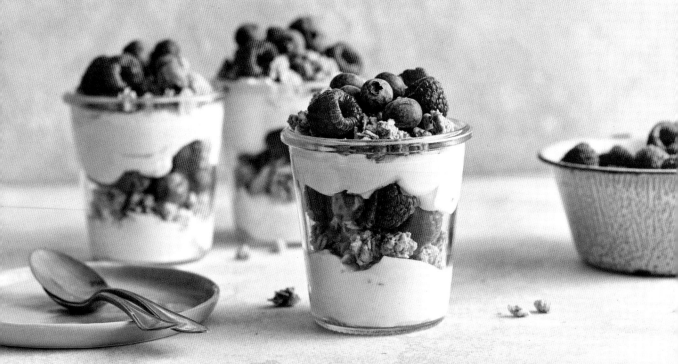

+ *Look at the focus on this one shot at f/7.1.*

One word of warning with wider apertures: Don't go too low. If you dial in a very low f-number, you might lose focus on your subject due to a lack of depth of field. The parfait image at f/3.5, for example, was shot with a lens that could go all the way to f/1.8. However, f/1.8 would have created too narrow a depth of field. I wanted to make sure the area of focus was wide enough so that the front of the cup all the way back to the middle of the cup was in focus. F/3.5 was the lowest f-number for this setup for the subject to be in focus while getting soft bokeh in the background. The key is to pick the aperture and depth of field based on your specific subject and the look you want to create. I always set aperture first for this reason.

Bokeh is more than a cool effect. It's a simple way to bring attention to your subject by isolating it within the frame. Our eyes are naturally drawn to what is most in focus. It's one of the many tools at our disposal to help direct the viewer's attention quickly to a specific spot.

Also, don't forget that aperture has an impact on your exposure. If you're going for something with a lot of bokeh and a narrow depth of field, remember that a wide aperture is also letting a lot of light into the camera. In that case, depending on the available light where you're shooting, you might need to adjust the shutter speed and ISO to counterbalance the aperture you've selected.

+ CHALLENGE

Create an image with bokeh. Whether using portrait mode on your phone or manipulating the aperture setting on your camera, take one shot of any subject using a narrow depth of field to produce bokeh in the background. That will generally be f/4.5 or lower if you're using a DSLR or mirrorless camera. If you're not getting as much bokeh as you'd like, remember that getting closer to the subject or having the background farther away will help to accentuate the depth of field. Experiment with moving closer to and farther from the subject until you get the desired amount of bokeh.

Take another shot of the scene with a wider depth of field, which is usually f/7 or higher. Adjust the shutter speed and ISO as necessary to balance the exposure. Compare your narrow depth of field image with your wide depth of field image. Does one more effectively draw the eye to your subject? Does one create a mood that you prefer? How does the depth of field change the scene?

If your images are especially blurry and nothing is in focus, go ahead and read the next section before completing this challenge. That should solve the problem, and then you can come back and reattempt the bokeh challenge.

3. HOW TO FREEZE
A MOMENT IN TIME

Have you ever wanted to freeze the action in a photo? Imagine pouring wine into a glass, dusting sugar on top of linzer cookies or drizzling fudge on a sundae. Capturing the split-second moment when the sugar falls from the sifter before it hits the surface of the cookie, like a sugar snowstorm, creates a visceral experience for the viewer. As you imagine these actions, do you see that sugar falling as a moving blur, or is it frozen in time, clear and still in the air? The shutter speed you select will dictate how this action will look in the image.

To review, the shutter speed is the length of time between the shutter opening and closing to capture your image. A slow shutter speed allows more light to hit the sensor because the shutter is open for a longer period of time. A fast shutter speed allows less light to hit the sensor.

Keeping that in mind, think about the relationship between time and movement. When you open the shutter for a longer period of time and movement is happening in front of the camera, the picture is changing, and those changes will be recorded in the final image. This is when you see the effect of motion blur. For example: those restaurant images where people pass through the space and they appear as blurred streaks across the frame. From the time the shutter opened to the time it closed, the subject moved, and that movement was captured as motion blur. This effect can be beautiful in food preparation shots like whisking egg whites, stirring a pot or rolling out dough. It gives life to the movement.

On the other hand, if the goal is to freeze action as it's happening, a faster shutter speed will be required. The shutter opens and closes so quickly that the moment is frozen. For a general pour shot like the coffee in the image to the right, 1/200 is a good starting place. If you're looking for super-crisp shots of a splash like you see in some commercial photography, then closer to 1/8000 will be the goal. But remember, the faster the shutter speed, the less light is reaching the sensor. That's why studio photographers doing high-speed action work rely on supplemental artificial light sources or the speed of a flashbulb to freeze the action.

One thing to keep in mind: Moving the camera will also impact the image, and this is extra-important to consider when using slow shutter speeds. For example, if you're shooting a plate of still food, but you are utilizing a slow shutter speed in order to get a bright enough exposure, you might end up with a blurry shot because your body is physically moving while holding the camera. Even if you try to stand perfectly still, you might move slightly, and if the shutter is open for long enough, that little bit of movement will be seen as motion blur. This is why a tripod is a food photographer's best friend for clear, crisp shots when shooting at slower shutter speeds. Otherwise, if you don't have a tripod and are shooting handheld, you will want to shoot at a shutter speed that's fast enough that it will freeze a moment. The general rule is to **select a shutter speed where the bottom number is double your focal length**. If you're shooting with a 50-mm lens, then 1/100 will be fast enough to avoid any motion blur from handheld camera shake.

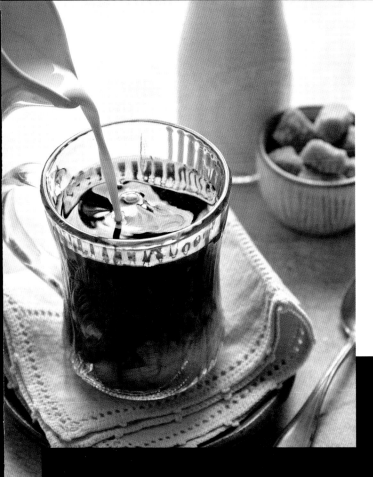

Finally, it also helps when capturing action to select an aperture that provides enough depth of field for both the subject and the action to be in focus. For example, in the coffee image to the left, I selected an aperture of f/6.3. It created a wide enough area of focus for both the glass, the coffee and the action of the creamer being poured to all be in focus while the sugar and milk carafe in the background fall into soft focus. The action is helping bring attention to the subject, so select a high enough f-number that allows the important parts of the image to be in focus.

+ *A shutter speed of 1/200 freezes the moment.*

+ CHALLENGE

Experiment with capturing action at different shutter speeds. First, think about an action that you want to capture. Consider asking a friend or family member to help execute the action while you shoot. Actions I especially love to capture are pouring creamer into a glass of iced coffee, sifting flour into a mixing bowl and drizzling syrup over pancakes. Do keep in mind that it will likely take a lot of attempts to capture the action the way you like it. Actions that can be repeated without having to refresh the food can be easier for practice purposes. Once you have selected your action and are ready to shoot, take a shot of the action at 1/100. Next, increase the shutter speed to 1/300, and take another shot. Then, slow it down to 1/60, and take another shot.

Compare your three images, and evaluate how the action looks different in the images at different shutter speeds. Which speed communicates movement in a way that you like? Play with different speeds, and get used to how shutter speed controls action. Don't forget that shutter speed also impacts your exposure, so you might need to compensate by adjusting your aperture or ISO.

+ PRO TIP

Not sure what focal length your camera's lens is? Focal length is read in millimeters and refers to the distance from the camera's sensor or film to the point where the light rays converge to create a sharp image of an object. In basic terms, the focal length determines how wide your angle of view is. If you are shooting with a 24-mm lens, or on a zoom lens that zooms out to 24 mm, you'll be able to see a wide angle and capture more within the frame compared to a longer, more zoomed-in focal length like 55 mm, 70 mm or even 200 mm. **A small focal length number is a wide view. A large focal length number is a small view.** Your camera's lens should have the focal length printed somewhere on it. Look for a number followed by "mm." Most DSLR and mirrorless cameras come with a kit lens that is an 18- to 55-mm zoom lens. That is a great lens to start with for food photography.

4. MAKE THE MOST OF SHOOTING
IN A DARK LOCATION

The third piece of the exposure triangle puzzle is ISO. As we discussed, it can brighten our exposure when the aperture and shutter speed aren't able to adequately compensate. For example, imagine that we're at our widest aperture at f/4.5 and locking in a shutter speed that's fast enough to shoot handheld, like 1/100, but our image isn't bright enough because we're in a dark location. That's when we rely on our ISO and increase it until the image is bright enough. But like the other settings in the triangle, ISO has its own unique impact on the image. **The higher your ISO goes, the more "noise" you'll start to see in the image.** Noise, also described as graininess, is a less sharp look. Noise isn't inherently bad, but for a lot of food photographers, a crisp, sharp image is preferred. On the next page, you can see the same image shot at ISO 10,000 and then at ISO 100. Comparing the two, you can see the visible difference in terms of sharpness, and the higher ISO also feels a little flat.

At the same time, I don't want you to be afraid of the ISO setting. Sometimes it's the only solution when shooting in a dark place. And luckily, as technology continues to advance, you'll hear more about cameras that perform well in low light. This means they are able to capture minimal noise even at higher ISO settings.

Also, grain and noise can sometimes be preferable to create a unique look or mood in your image. ISO can be an awesome tool for both exposure and creative reasons, so don't be afraid to explore it with your camera.

+ CHALLENGE

Capture several images of a subject at different ISO settings. Continue to increase your ISO with each shot and assess the level of noise. Remember, as you increase the ISO, you will need to adjust the aperture and/or shutter speed to compensate to keep a properly exposed image.

Or, you can go into a darker space where a higher ISO will be required. As you continue to increase the ISO, take note of the ISO setting when the noise in the image starts to become obvious. It's good to have an idea of the threshold for your specific camera so that in future shoots when you need to use ISO, you'll know how far you can comfortably increase it without compromising your desired image quality.

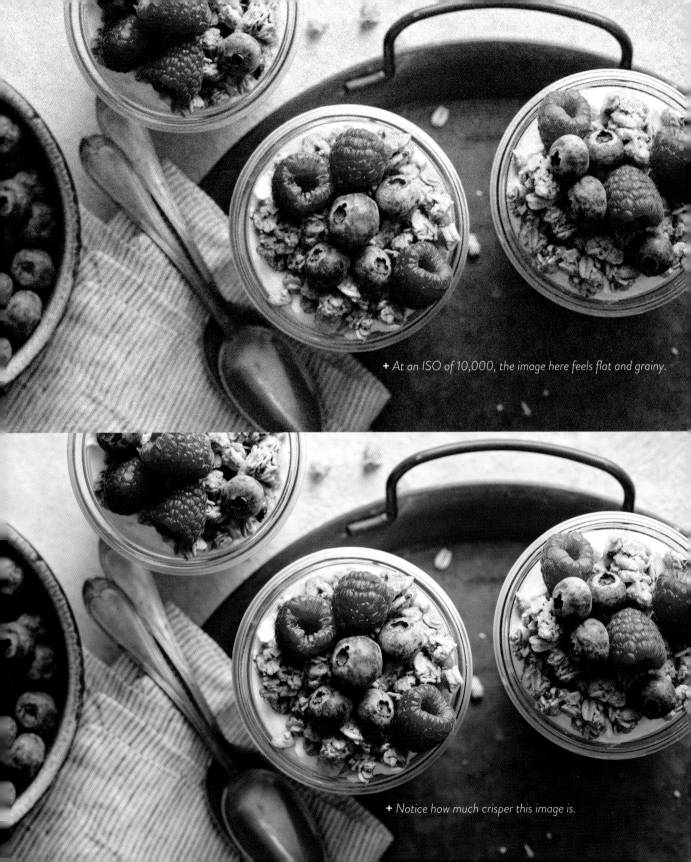

+ At an ISO of 10,000, the image here feels flat and grainy.

+ Notice how much crisper this image is.

5. HOW TO KNOW IF AN IMAGE
IS BRIGHT ENOUGH

Now that you're familiar with aperture, shutter speed and ISO, the next step is to evaluate if your image is bright or dark enough. Some people rely on the camera's meter to tell them if the image will be properly exposed, but I'm here to ruffle some feathers and say that I don't pay attention to that. I prefer to rely on the histogram and assess it for every shot I take.

The histogram is a visual representation in graph form of the quality of the tones present in your image. You can access the histogram in your editing software, like Adobe Lightroom and its equivalent mobile app for your phone. It's also typically accessible on your camera's LCD screen when you're reviewing an image or working in live-view mode.

The histogram plots every pixel represented in your image on a graph ranging from pure white to pure black and all the grays in between (also called mid tones). If you have a lot of lighter and white tones in an image, you will see the graph is mostly populated on the right side of the histogram. If you have an overall darker image with a lot of dark grays and ranging to black, the pixels will be more densely represented on the left side of the graph. There's no such thing as the perfect histogram because every image will be unique in its distribution of pixels and tones. But it is good to have bright and dark tones present throughout the image so that your image isn't underexposed or overexposed.

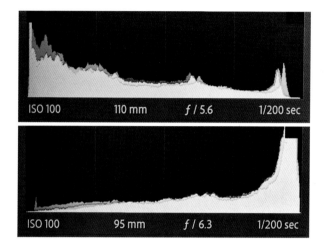

ISO 100 110 mm f / 5.6 1/200 sec

ISO 100 95 mm f / 6.3 1/200 sec

For example, imagine you have a dark and moody image with a lot of dark tones. If you look at the histogram and see a gap on the right side (indicating that there are no bright tones present at all in the image), that's an indication of an underexposed image. Even in a dark shot, it's good to have bright tones present to create contrast and bring attention to your subject. Looking at the histogram for my dark bagel shot, you see that there are a lot of dark tones represented on the left side of the histogram, but there are still some bright tones present on the right side allowing us to see the bagel in the midst of the dark and moody vibes.

The same principle applies for bright and light shots. If there aren't any dark tones present, you're likely looking at a flat image that's lacking some shadows that would give it depth and a sense of three-dimensionality. You'll see my bright bagel shot has darker tones present to give it definition and depth.

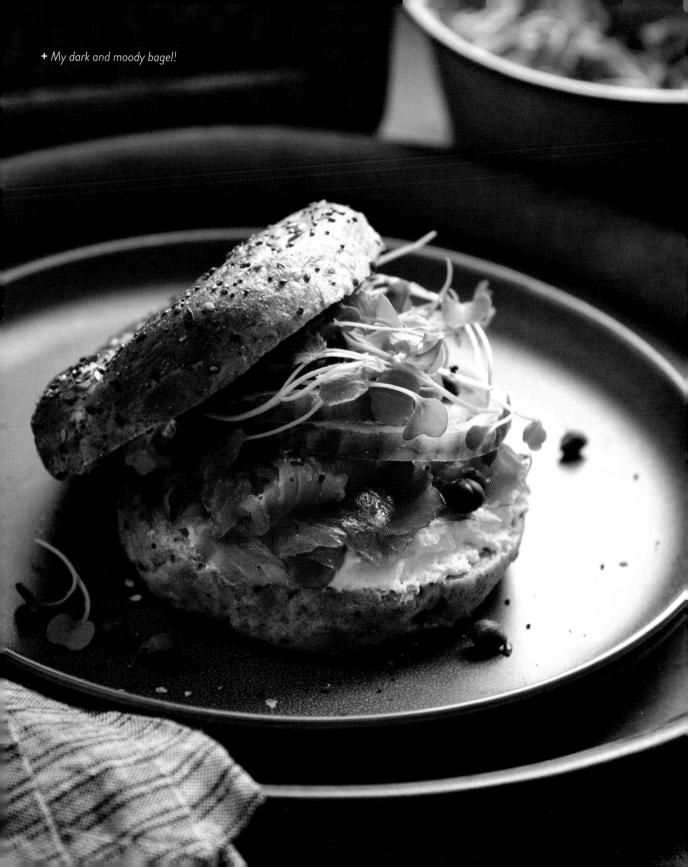

+ *My dark and moody bagel!*

Also bear in mind that it's helpful to keep the tones within the range of the histogram. If you accidentally dial in camera settings that create a super bright, overexposed image, you will see the pixels on the histogram are all bunched up on the right side. Some of the white pixels are so bright that they're off the scale, surpassing the graph. That's called "clipping the highlights," and the information about those pixels is gone. You'll also hear this referred to as the highlights being blown-out.

Likewise, the same can happen to the black tones. When they exceed the left side of the histogram, those are "clipped shadows." It's advised, especially for photos that will be printed, to keep pixels within the bounds of the histogram and to avoid clipping the highlights or shadows.

+ CHALLENGE

Open an image in the software or app you're using for editing photos and locate the histogram. Move the exposure slider to the right to increase exposure and watch what happens to the histogram. It should shift all the pixels to the right. Move the exposure slider to the left, and it should shift all the pixels to the left, representing a shift toward darker tones.

Set up to shoot a subject, implementing all the skills you have learned thus far, and while you select your settings, keep an eye on the histogram. Pay attention to the right side and the left side of the histogram, and manipulate your settings until you have created a properly balanced exposure that shows a distribution of tones across the entire graph.

Make referencing the histogram a habit during your shoots because it will give you a clear idea whether you need to increase or decrease your exposure through manipulating aperture, shutter speed or ISO.

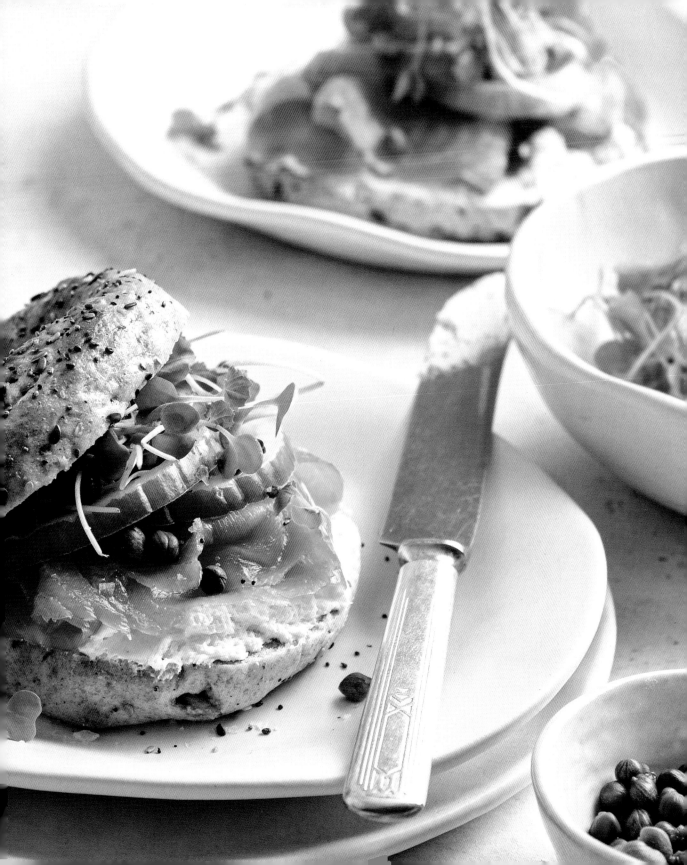

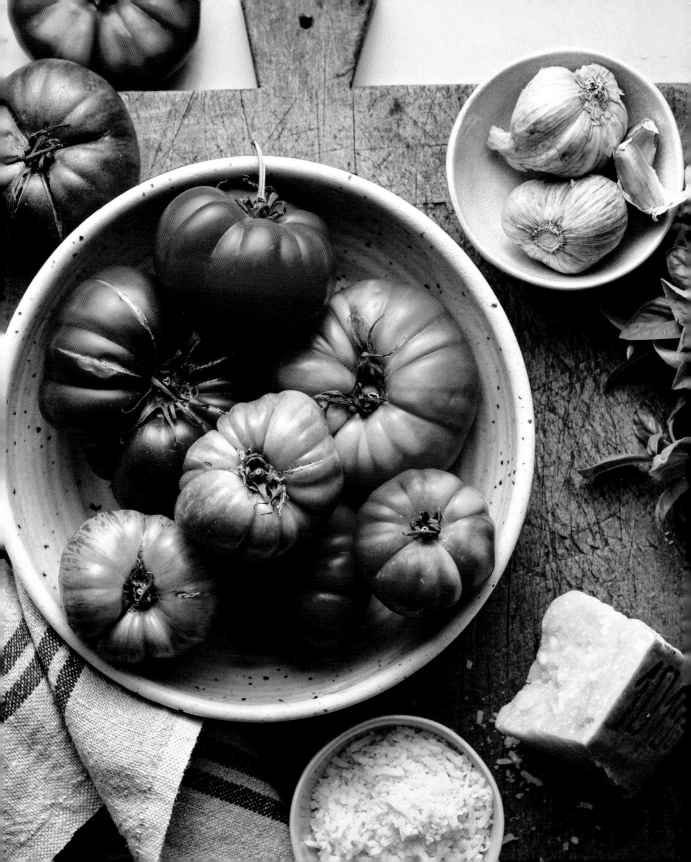

LIGHT AND SHADOW

Taking Charge of Your Most Powerful Tool for Standout Shots

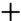

In this chapter, you'll learn to wield the most powerful tool you have in creating top-notch food photos. Light may seem mysterious at first, but it predictably follows strict rules every time and everywhere. The next step in our journey is to understand the basic science behind light so you can add your own artistic flair to your images.

6. FIND THE BEST LIGHT
IN THE HOUSE

How do you find the best light in a given space? The answer depends on the kind of lighting that you want to create to best suit your subject. When you have the ability to diagnose the light, it's easier to manipulate it to create the look you desire.

During the early days of my first food blog, I would prepare a dish and then run it all over the house from window to window, looking for the most flattering light. I knew that sometimes some of the windows in my house would provide fantastic light. The problem was, I didn't know why.

To understand light, you have to become a student of shadow. Study shadows to observe their qualities. Are they hard, soft or somewhere in between? The quality of the light lies in the transition area from the light to the shadows. When the transition is quick from dark to light—as if there's a straight hard edge to it—that's hard light. But when that transition is gradual—slowly morphing from dark to light—the light is softer.

Compare the tomatoes in the two images on pages 29 and 30. Can you see the difference between hard and soft light? Do you see how it changes the energy and feeling of the image? Does the light tell a story about these tomatoes? Where they are in the world? What time of day it is?

I imagine the hard-light image is captured on a bright, sunny weekend, midday at the local farmers' market. The soft-light image reminds me of tomatoes on my countertop at home next to a big window, ready to be sliced for a tomato galette. You can see that both types of lighting are effective and bring a unique quality to the image. Neither is better nor worse, right nor wrong. Selecting the lighting you desire for an image is a personal choice.

Now that you can diagnose the light, the next step is to know how to find it or, better yet, create it. **There are three keys to lighting that will help to make the most of any window: the size of the light relative to the subject, the distance from the light to the subject and the amount of diffusion of the light.**

First, the larger the light source relative to your subject, the softer the light will be. Note the use of the word "relative," because that is important. The best way to see this is in action. Find a window, place a subject in the light coming from the window and evaluate if it's creating hard or soft light.

Next, assess if the light coming through the window has a direct line of sight to the sun or not. If the sun is beaming directly through the window and throwing light onto your subject, there's a good chance you will have hard light, and it will create dramatic, high-contrast images. That's because the sun relative to your subject is very small because it's very far away. But, if the sun is on the other side of the house or there is an overhang over the window providing shade, you have indirect light, which produces softer light. This is because the window has become the light source and is rather large relative to your subject. This is why natural light photographers gravitate toward north- and south-facing windows, as they generally provide indirect sunlight that creates soft light.

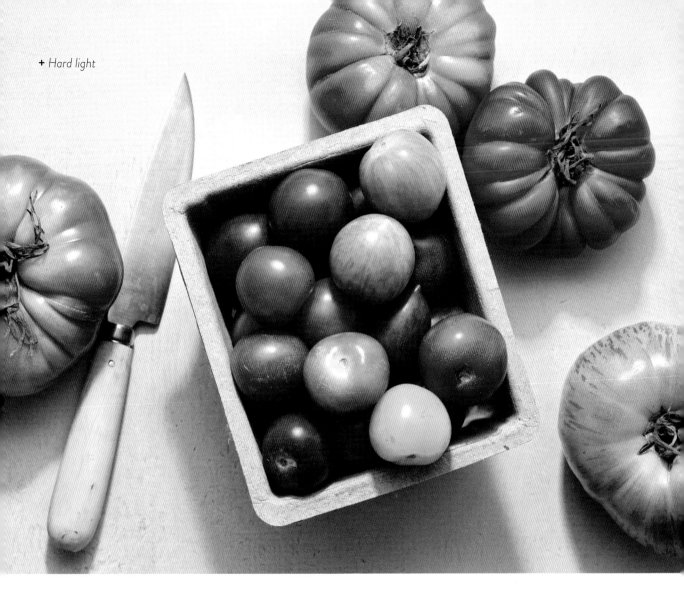

+ *Hard light*

Want even softer light? Find a larger window with indirect light. I have a large floor-to-ceiling south-facing window in my kitchen that I like to use for this reason. Also, take advantage of the second key to lighting and move your subject closer to the window because the relative size of the window increases the closer the subject is to it. This will also help with your exposure settings because the light is more intense the closer the subject is to the light source.

I'm focusing more on soft light because it is generally easier to work with and creates a flattering look for food and portraits. Although, some food photographers are obsessed with hard light. If that's you, go for the direct sunlight and small windows.

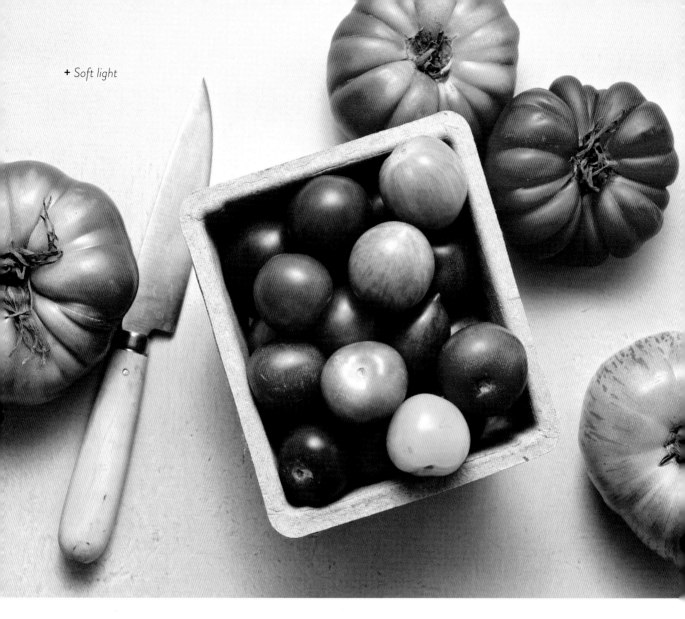

+ *Soft light*

Going back to your test window, you might have a situation where you want soft light but all you have is direct sunlight beaming through your windows. That's when we can rely on the third key to lighting by adding diffusion. When light is coming from the sun or any other small, bright light source, the light rays are intense and direct. We can add a layer of material between the sun and our subject so that the direct rays are broken up and scatter softly onto the scene. By diffusing the light, there is no direct line of sight to the sun anymore, creating a larger light source relative to our subject and softer light.

Diffusing light can take on many forms. Clouds are one of the most natural sources of diffusion. Go outside and look at your shadow during the next overcast day. Chances are you will see a gradual transition in the shadows.

+ *My large, south-facing windows can create beautiful indirect lighting at the right times of the day.*

+ *When the light is harder than I want for my photos, I add my large 150 x 200-cm 5-in-1 reflector.*

If you don't have clouds and want soft light for your food photos, you can simply draw a sheer white curtain over the window and watch the hard light turn soft. Photography gear retailers also sell diffusion materials specifically for photographic lighting. Another popular option that can be found online and is easy to use is a 5-in-1 reflector.

Be aware that the thickness of your diffusion material will have an impact on the quality of the light. The thicker the diffusion material, the softer the light.

As you approach any window or light source, always keep in mind the three keys of lighting. They will help you problem-solve the lighting in any location.

7. USING THE COLOR OF LIGHT
TO MAKE IMAGES TRUE TO LIFE

Have you ever tried to photograph your food at a restaurant and the colors look off? Do the white plates look orange or yellowish? Does the food look less than appetizing? The solution to this problem is in understanding white balance.

First, it helps to understand that light can vary in its color temperature in terms of where it falls on the Kelvin scale. 1,000 Kelvin is a warm, orange-red candlelight. The opposite end of the scale is the cool blue color of twilight at 10,000 Kelvin. Right in the middle of the scale is brilliant white daylight at 5,600 Kelvin.

Fortunately, our cameras are equipped with the ability to counterbalance these different temperatures of light. In light color theory, if we add blue to orange, it balances to white. So, if you are shooting under warm, cozy, orange lights like those found in restaurants (sometimes referred to as "tungsten"), the camera can shift the white balance by adding in some blue and making the white plate appear white, and the whole scene will appear more true to life. Look for the "white balance" setting on your camera, also sometimes represented as WB, to manipulate this setting.

However, white balance can go awry when you're in a location with multiple lights that are different color temperatures. For example, in my kitchen at home, there is natural white daylight coming through the windows at 5,600 Kelvin, but then there is also warm orange light from the overhead incandescent lights at 2,700 Kelvin. Taking a picture with these two color temperatures happening together results in color cast issues because there's not one correct white balance setting for the camera in that situation. The easiest way to improve the color of your images is to ensure you're dealing with only one color temperature in the lighting.

+ CHALLENGE

Grab some eggs and find a location where you want to photograph them. Assess the lighting in that space. Are there multiple light sources that are different color temperatures? If so, find a way to simplify the lighting so that you are only working with one color temperature.

Take a shot with the camera set in auto white balance and look at the image. Are the white eggs white? If they are, you've achieved proper white balance in your photo. But, if they look a bit blue or a little orange, then it's time to try out some of the different white balance setting options. Try the daylight setting, shade and tungsten. Try all the settings, and see if one gives you a more accurate white balance. Some cameras also have the ability to select the specific Kelvin temperature. For example, when I am shooting in my home studio in natural light, I will often set the camera at 5,200 Kelvin. This setting gives me the most balanced look for that particular environment. Experiment and become familiar with changing white balance so that no matter where you're shooting, your colors will look true.

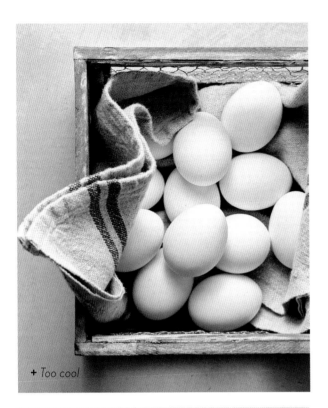

+ *Too cool*

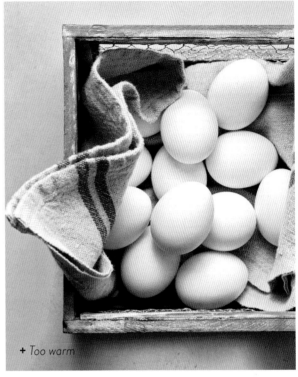

+ *Too warm*

+ *Just right!*

+ PRO TIP

Once you feel you have a firm grasp of your camera's settings, explore the option of shooting in RAW. Most likely your camera currently shoots in JPEG. RAW is a file format (appearing as .CR2, .NEF, .ARW or .DNG depending on your camera) that doesn't compress your images and allows you greater flexibility to correct color and exposure in editing. However, RAW files are rather large and require you to process your images before being able to share them. As you advance your skills, this can be a helpful tool.

8. THE DIRECTION OF LIGHT
THAT FLATTERS YOUR FOOD

Imagine an English muffin. Split it down the center so that you can toast it before making the most epic breakfast sandwich. Before you pop the two halves in the toaster, pay attention. The irregular surface, the nooks and crannies . . . that's texture. Same goes for smooth surfaces, fuzzy surfaces and shiny surfaces. Food photographers love texture.

Texture is one of the keys to unlocking our salivary glands and making food look desirable. The easiest way to show off the texture of a food is with light and shadow. But don't miss that shadow part. Yes, I am obsessed with light, but you can have too much of a good thing. Too much light coming from multiple directions falling onto your scene can mean your image lacks shadows. **Shadows are the key ingredient to create depth and three-dimensionality in our images.** Without shadows, we can't see the form and texture of our food. It's the shadows getting trapped in the nooks and crannies that tell our brain what kind of texture we see without having to physically touch the subject.

Burgers should be juicy, bread crusty, tomatoes bursting with flavor and cocktails cold and frosty. The best way to communicate the important assets of a food is to show off the texture through applying light and shadow in an intentional direction. There are three options when it comes to the direction of the light: front, side and back.

My first photography lesson as a kid was while on vacation with a disposable camera. My dad instructed me to shoot with the light behind me as the shooter so that it would illuminate the faces of my family. That is considered front lighting, and it is great for shooting portraits because it fills in all of the texture in our faces. But, if we were to shoot our Parmesan on the next page with front lighting, it wouldn't show off the crumbly texture of the cheese because there wouldn't be any shadows. This is the reason why photographers tell you not to shoot your food with the built-in flash. When the light is hitting your food from the front, you lose the texture and dimension. Plus the camera's flash is a very small light source that creates harsh lighting.

Instead, we can light our Parmesan in such a way that the light enters from the side of the scene. That means that the window is generally to your left or right side. The light hits the mound of grated cheese on one side, capturing bright highlights and then wraps around until it fades into shadow. This side lighting reveals three-dimensional form in a two-dimensional medium.

Backlight flies in the face of those early family vacation photo lessons. I vividly remember being told, "Don't shoot into the light!" That was fair advice in those circumstances, with a disposable film camera that couldn't tell the window from family members and would most likely create an exposure that would leave my little sister as an unrecognizable shadow on a bright window background. Fortunately, the digital age allows us to see what we're shooting in real time without having to drop off film at the pharmacy. We can experiment with shooting backlit with little consequence.

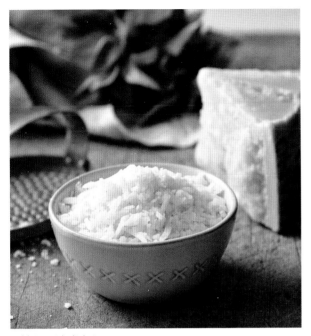

+ *Using side lighting*

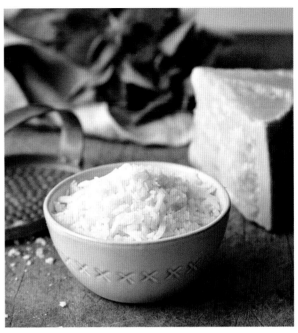

+ *Using backlighting*

Backlighting is one of my favorite techniques and can make the right subjects positively sing. Dishes like pasta, salads and soups are prime candidates for backlighting because the light has the ability to wrap around from the back to the front of them because they're not especially tall. Check out the second Parmesan example. The light is moved farther back from the previous example so that it's entering from behind the subject. It creates highlights that pop up off the surface of the food. This gives it a bit of sparkle and glow while casting the shadows forward toward the viewer, showing off a bit more texture on the front of the cheese. You can find other examples of backlighting in this book including the drinks on page 127 and the peach pavlovas on page 69. Backlighting doesn't work for all subjects in all situations, but at the right moment, it can create magic.

+ CHALLENGE

Find a food with a lot of texture, such as bread, grated cheese or crackers. Take it to your shooting window and place it in the light. Study how moving the food and your perspective change the way the shadows appear. I dare you to extract the maximum texture in those nooks and crannies by experimenting with side lighting and backlighting. Take your time and find which lighting suits that subject best in order to show off its texture. Capture some images of this texture-fest and share them with your fellow food photographers by tagging #pictureperfectfood.

9. FINDING THE SPARKLE
FOR IMAGES THAT LOOK LUSCIOUS

Here's a technical term that will convince people you're a pro food photographer: specular highlights. They're those little sparkles that reflect off the food to tell us that a tomato is juicy, the cheese is hot and melty and the chocolate is warm and ooey-gooey. A drool-worthy slice of pizza will be chock-full of specular highlights.

Specular highlights are created when a light source hits a shiny surface at a particular angle relative to our camera, bounces back into our camera and is seen as a direct reflection. It's a mirror reflection that's just as bright as the main light source.

The techy photographers will tell you all about the angle of incidence and the angle of reflection and formulas that make my brain go into sleep mode. My advice is to simply move the food around and see the sparkle happen for yourself. Your goal is to develop an intuitive sense for knowing that if you tilt something shiny in a particular direction relative to your light source and your camera, it will give you specular highlights.

+ The specular highlights in this image were achieved by tilting the tomatoes at just the right angle toward the light.

+ CHALLENGE

Tomatoes are one of my favorite subjects for playing with specular highlights because of their irregular shapes and interesting interiors. Any kind of citrus will work here, too. Slice up some tomatoes and head to your shooting window. If they're larger tomatoes, go for slices; if they're small, slice them in half. First, without your camera, look at your sliced tomato from the vantage point you plan to place your camera. Imagine your eyeballs are the lens of your camera. Now look for specular highlights. Do you see any? Keep your head in the same position, but now turn the tomato a quarter turn. Are there more highlights? Fewer highlights? Tilt the tomato toward the window light. Highlights, check! Tilt the tomato away from the light. Where did the highlights go? You will start to notice that slight movements of the subject alter the amount and placement of the specular highlights.

Now, it's time to capture these elusive specular highlights. Put your camera in the position where your head was, and position the tomato in the way where you had the best, most mouthwatering specular highlights and see if you can capture them.

Continue to adjust the tomato. You can also adjust the camera angle, too, and see how that impacts the highlights. Over time, as you continue to practice chasing specular highlights, this will become second nature and a favorite tool as a food photographer. But, don't forget, the surface of the subject has to be shiny for it to create a direct reflection. And now you know why food stylists are always dabbing extra oil or moisture to the food to keep that shine alive. Bring on the sauce!

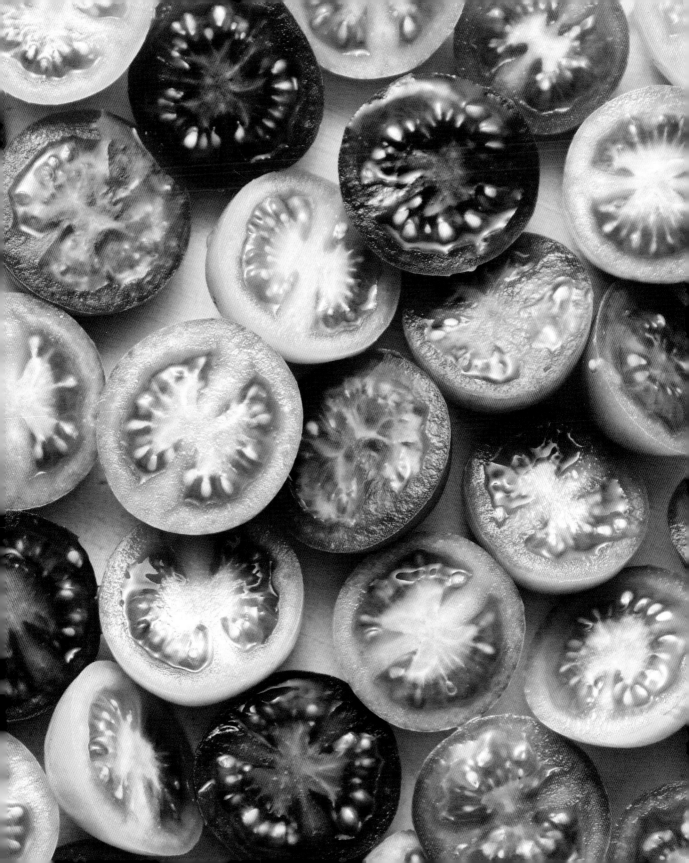

10. USING MIRRORS AND REFLECTORS
TO MAKE YOUR FOOD THE STAR OF THE SHOW

Do you like being the center of attention? Regardless of your personal thoughts on being in the spotlight, it's always good for your subject to be the central figure. That doesn't mean I have to put my primary subject, also referred to as the hero, front and center for it to be noticed. But it does need to stand out. One way we can bring attention to our subject is by adding a little more light in a very specific spot to highlight it. Literally, add some highlights to the subject.

Returning to the physics lessons, light has the ability to bounce off reflective surfaces. White foam boards, aluminum foil, mirrors . . . any one of these surfaces can be utilized as a reflector to bring light in a very intentional way to our scene.

I shot the garlic images on the next page three different ways. None of these are right or wrong. They're simply different. The first one I shot in the light of the window with a hefty dose of shadow on the right side. I personally love moody shadows. Then in the second image, I added a white card to the right side. The white card catches and bounces the light back onto the garlic and surrounding subjects. You can see how it has illuminated much of the right side of the whole scene. **The official term for this kind of lighting technique is fill light because it fills in shadow areas with a light that's a bit less intense than the main light, also referred to as the key light.**

Finally, in the third example, you can see I replaced the white card with a small mirror. It's bouncing light only on the garlic and not reaching to the background area. This is due to the fact that it's much smaller than the white card and that mirrors produce a more direct, focused reflection compared to white surfaces that bounce a scattered diffused light.

+ PRO TIP

Don't fill in all the shadows because we don't want to lose the depth and three-dimensional quality in our images. Shadows are an important part of the equation. The job of a pro photographer is to maintain the balance of light and shadow, manipulating and placing both in order to most effectively bring attention to our subject and tell the story of our scene. If you can balance key light, fill light and shadow in an image, you are well on the way to working with light like a pro.

+ CHALLENGE

Find something around your house that is able to reflect light. This can be a white sheet of paper, white foam board, a white folder, a baking sheet covered in aluminum foil, a makeup mirror or a larger mirror. There are endless options. Select one and go to the spot where you like to take photos. Select any subject and place it in your window light and position your camera so you can capture the subject with side light.

Use the reflective surface you selected and position it opposite the light source. Start moving it around, tilting it in different positions to see how it bounces light onto your subject. Pay attention to the placement and proximity of the reflector and how that affects the intensity of the light hitting your subject. Once you feel comfortable with how the light bounces and reflects, create an image using reflected light in a way that brings life and attention to your subject.

+ *Behind the scenes of my no fill light shot*

+ *Behind the scenes using the white card*

+ *Behind the scenes using a mirror for reflected light*

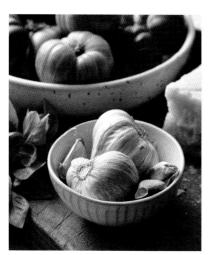

+ *No fill light*

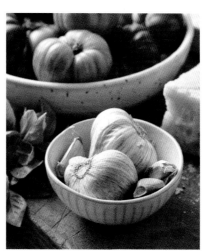

+ *Using a white card to bounce the light*

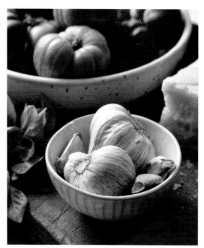

+ *Using a mirror to produce a direct, focused reflection*

11. PLAYING WITH THE SHADOWS
TO CREATE CAPTIVATING ATMOSPHERE

If you have read the preceding sections, you already know how important shadows are. They indicate depth and dimension. They tell stories. But we can take the shadows further with low-key photography.

Low-key photography is when the main light—the key light—in the image is intentionally restricted and most of the image falls into the shadows. A small sliver of light hits the subject to bring it to life and in contrast with the rest of the dark scene. It's like a small crack of a door in a dark room, illuminating only the things in the path of the light entering from outside.

This look is rather easy to achieve if you're in a dark room and have dark curtains covering your windows. Simply create a little opening in the curtains to allow a beam of light to fall onto your scene. Place your subject in the path of the light and watch the magic happen.

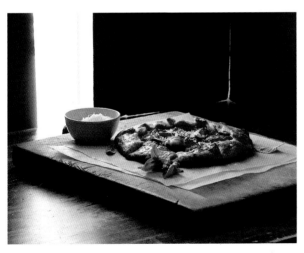

+ *In addition to this dark and moody galette, the burger on page 115 was also captured using the low-key lighting technique.*

But perhaps you don't have dark curtains or need to restrict the light in another way. Pick up some black foam board at your craft supply store. Position two pieces on the edge of the scene nearest the window in such a way to replicate the look of drawn curtains. You can also imagine they are barn doors just slightly cracked. This act of blocking the light can turn a dish of food into a painterly work of art.

+ PRO TIP

When shooting low-key photography, be sure you're basing the exposure on the brightest part of the image—in theory, the hero dish. If your camera is in automatic mode, it might base the exposure on the dark parts of the image, causing your subject to be overexposed and everything in the shadows to be visible. The goal with low-key photography is for the bright parts to be properly exposed and the rest to fall to darkness. Hopefully you're feeling more confident shooting in manual mode and more in control of your exposure. If you're not, you can always revisit prior lessons and further solidify your skills.

+ CHALLENGE

Capture an image where you intentionally limit the light in the scene. You can use curtains, black cards or even black three-ring binders propped up on their sides. It is important that whatever blocks the light be black or at least dark gray since lighter cards reflect light. The key is to subtract the light from the scene, but still allow the light to illuminate your subject. Experiment with limited light and bring special attention to your subject. Even if you love a more light-and-airy look, it's worth taking a ride on the dark side to see what you can create.

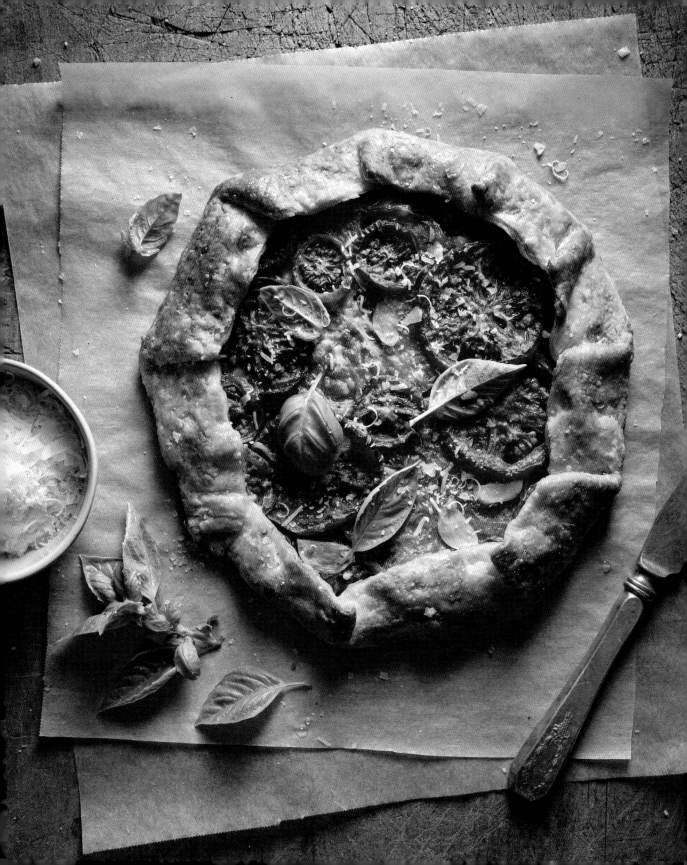

STORY

Creating Expressive Images That Connect with Your Viewer

Food photography is more than shooting pretty pictures. Outstanding images captivate and transport us to a specific place and time, seeing a food from a particular perspective. Storytelling is the vehicle that allows the photographer to uniquely connect with the viewer. In this chapter, we'll explore the various methods of storytelling so you can tell your own story through your images.

12. HOW TO INFUSE YOUR OWN STORY
INTO YOUR IMAGES

Food is universal. From tacos to tapioca, food is more than flavor. The smell of bacon cooking in the kitchen takes me straight to Saturday mornings as a kid when my mom made special breakfasts for my sister and me. A cake baking in the oven reminds me of birthdays gone by. The ability to communicate with our images, not just the components of the dish but also those unique feelings and experiences . . . that's when you've tapped into the power of visual storytelling. **We can connect to a viewer through our own unique experience and perspective, infusing an image with our personality and history, taking a food photo past mere documentation and creating a connection.**

I find it fascinating that I can look at an image of a dish I've never tried, within the context of a story I've never experienced, and feel connected to it. As food photographers, we use light, color, texture and propping to fill the frame with clues that can convince a viewer that a story is taking place. The more specific you are about the details of the story, the more meaningful it will be.

As you thumb through the pages and images within this book, you might notice each chapter's images have a theme and a story. Chapter 1 is all about breakfast. Some of my favorite childhood memories are from a little breakfast joint in our neighborhood. I prepared for shooting those images by meditating on the sights, sounds and smells of that restaurant, paying close attention to how they made me feel. I remember the bright, soft morning light and the pale blues and mauves in the decor. I remember the warmth of the dining room and the excited anticipation of breakfast sandwiches and their decadent granola parfaits. I remember the shine of the light off the metal handle of the syrup dispenser. Cast-iron skillets. Tchotchkes. Silk flowers. These memories informed my creative decision-making and are infused in the final images. It's these choices and vision that make the images uniquely mine and hopefully connect you to a feeling that makes the images more engaging and memorable.

"Specificity is the soul of narrative." —John Hodgman

+ CHALLENGE

Think about a dish that holds important memories for you. Get out your notebook and pencil and write down words and phrases that come to mind when you think of that food. Imagine the smells, the feelings, the colors. Where do you eat it? How is it served and plated? What's the temperature of the food *and* the room? What's the time of day and the feeling in the room? Write down at least fifteen thoughts and memories. No detail is too obscure.

Using this list, think about how these memories can be communicated visually. Should you apply hard light or soft light? Is the space light and airy or does it feature a predominant color scheme? Are there textures you should consider when selecting props? Rugged and worn or shiny and modern? Write a note next to each memory and how that concept can be communicated visually. Use this list to make choices in crafting a scene and capturing an image featuring your selected dish. Don't be afraid to put your own personality into it. The more of the story you share, the more opportunity you have to make a lasting impression on your viewer.

13. ADDING COLOR
TO EXPRESS A MEANINGFUL MOOD

Colors are a powerful storytelling device. Chances are, you are already familiar with the color wheel and perhaps even have a sense of how different colors affect our mood. Red can be energizing or feisty. Blue can be cool and contemplative. But colors communicate infinitely more information than the basics we learn in elementary school art class. A slight variation in the quality of a color can significantly impact the story being told, and an intimate understanding of color can captivate your viewer. **To understand color, it helps to understand the concepts of hue, value, saturation and temperature.**

Hue is how we define and differentiate between the colors on the color wheel: red, orange, yellow, green, blue and purple.

The **value** of a color defines its darkness or lightness. If we have a true yellow and we add a bit of black to it, it makes it darker and gives us dark yellow. On the other hand, if you add a bit of white to that true yellow, it becomes a lighter yellow.

Saturation describes the intensity of a color or its fullness. If you have a green napkin, is it a vivid, fully saturated green, or is it more muted? As you start to compare colors in images, you'll see some photographers enjoy more intensely saturated, bold colors, while others opt for subtler and less-saturated hues. Both styles are effective in communicating a unique story.

Finally, **temperature** describes the warmth or the coolness of a given color. Adding blue to any color will make it cooler, even to warm hues like red. If you add blue, it becomes a cool-toned red. Similarly, adding a warm hue to any color can make it warmer. Adding some yellow to green will make it a warmer green, as opposed to adding blue, which makes it a cooler green.

These qualities of hue, value, saturation and temperature are what influence the differences between the millions of colors visible to the human eye. But what I find even more interesting is how shifting the value, saturation and temperature of a hue can tell a story.

For example, what does a vibrant, warm, red napkin say vs. a cooler, darker, burgundy napkin? Or an electric, eye-popping, yellow background vs. a muted, soft goldenrod? When I use light pastel colors in a photo, it feels much more playful and innocent. When I use darker, richer, cooler colors, I'm typically trying to express something more serious or introspective.

As you start to look at images, take note of the value, saturation and temperature of the colors and how they make you feel. Understanding and applying color starts with thoughtful observation. The more in-tune you are with the quality of colors and how they make you feel, the more you'll be able to apply them effectively in your images to tell your story.

+ CHALLENGE

Let's start to train your eyes. Find six or more swatches of colored paper. These can be torn out of magazines, from your kids' craft supplies or paint swatches from your local hardware store. If you want something more formal, you can find Color-aid paper packs at art supply stores that are intended for activities like this one. The swatches you select can be different hues or the same; that's your choice.

First, line up the swatches in value order. Start with the one with the lightest value and move through to the darkest. This will be harder than it sounds. If you find yourself staring at two colors, wondering which is lighter, you're on the right track to training your eyes. Some colors will be extremely similar in terms of value, so do your best. You can also consult with friends and family to get their take on the value. The fun part is that different people will have different opinions. Opinions are endless in the art world. Line up your swatches in order of saturation, from the most intensely saturated to the least. If the value exercise didn't cause you frustration, this exercise will. Whenever assessing saturation, I always ask myself, "If I added more green to this green would it make it more green or is it as green as it can be?" Talk about meta!

Next, line up the swatches in order of temperature. Once again, you'll wonder when differentiating colors became such a difficult task. But, I promise, this investment of time is well worth the effort. Finally, spend a few minutes with each individual swatch and write down the feelings and thoughts you associate with that color. What memories come to mind as you're meditating on the hues? Do any of the colors put you on edge? Is there one that's calming? Does one make you excited or energized?

In case you want a bonus exercise that will put you at the front of the color class, do this exercise regularly with different swatches. You might find this process frustrating, but the good news is that by sheer virtue of going through these exercises, you've strengthened your ability to understand and see color. The more you see the nuances of colors and intuit the feelings associated with them, the more you can start to make informed decisions about selecting backgrounds and props that suit the mood you're looking to achieve in an image.

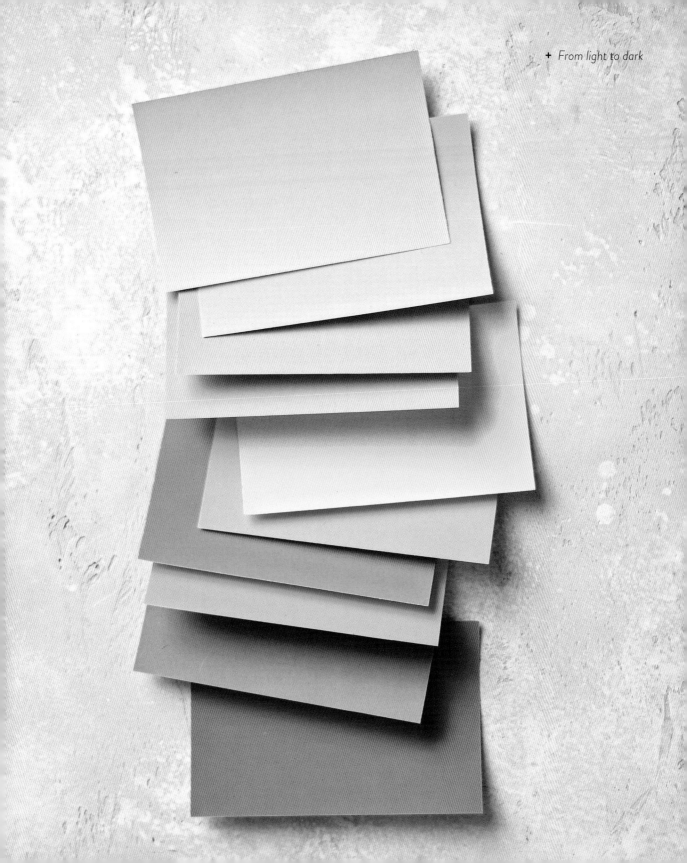

14. CAPTURING PROCESS SHOTS
TO DIG DEEPER INTO A DISH

It's not all about the final dish in food photography. Capturing the process of making food is equally beautiful and an excellent device for transporting our viewer and telling them the story of preparing a dish.

I always keep two things in mind when capturing a process shot. First, I ask, "Where am I shooting?" Certainly, the vast majority of cooking happens in a kitchen. But kitchens can be a tricky environment for a photographer when considering available light and cramped spaces. And if it's a restaurant kitchen, things move quickly. **Take time to think through how the space will affect decisions such as the white balance you select, whether or not you need any artificial lighting for dark spaces and what lenses you will need.** The other option is to shoot the process in a different location. For example, my kitchen has dark cabinets and countertops, so when I'm shooting at home and I want to capture a process shot for a recipe, I relocate to the dining room, which has big beautiful windows and a lot of white space. This requires a bit of staging, but ultimately gives me a final image that's closer to what I have in mind.

The other consideration when capturing process shots is to think through the recipe's steps and imagine which will be the most mouthwatering or interesting to capture. Which steps engage memories in the kitchen? Which are dynamic or unique? Does the recipe feature photo-worthy ingredients? For example, when baking the cake for this chapter, a few things came to mind. For one, I remember being a kid and how my mom cracked eggs using her egg separator. I knew I wanted to capture a few shots of the eggs being cracked or of spent egg shells next to the mixing bowl. I also thought about how deliciously beautiful it is watching cake batter being transferred from the mixing bowl to the baking pan. I wrote these ideas down, creating a shot list. I go into every shoot, large and small, with a shot list to help keep me organized and on track—similar to a script for a play. Certainly, you can change things up and improvise once you get into the shoot, but having a thought-out plan ahead of time will help prevent missing out on important process shots.

+ CHALLENGE

Select a recipe that you would like to photograph. If you're not a cook, find someone who is willing to prepare a dish and allow you to photograph the process.

Read through the recipe and in your notebook, write a list of different steps in the cooking process that you think lend well to being photographed. Think about important actions and ingredients. For example, if you're working with a chef who is making pizza, write down things like kneading the dough, shredding the cheese and adding herbs and spices. These notes will become your shot list. Then, if you want to take it a step further and do some reading ahead, for each shot, think through camera angles (see page 92), props (see page 57), wardrobe considerations and lighting. It's a lot to keep track of, but the more you go through this process, the more it will become second nature to plan your shoots.

Once you know what you're shooting, set to the task of capturing process shots. After the shoot, look through the images and compare them to your shot list. Did you stick to the shot list? Did you capture things you hadn't planned? Was there a challenge you didn't foresee? Take these lessons and apply them to your next shoot. As you continue to execute more shoots, you will see exponential gains in the quality of your images and the speed of your workflow when capturing process shots.

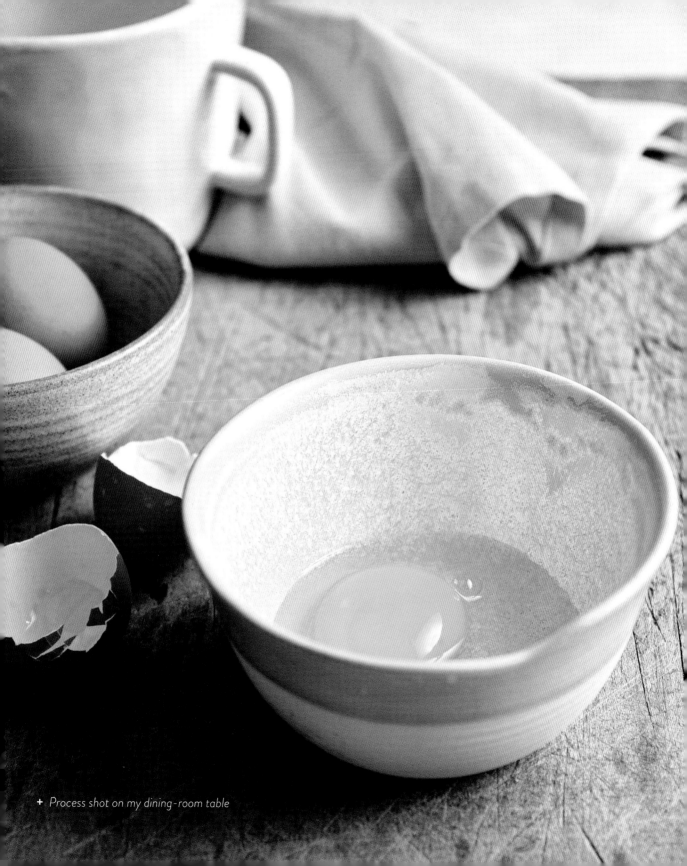

+ Process shot on my dining-room table

15. USING IMPLIED MOVEMENT
TO HOOK THE VIEWER

Food photography is classified as still life, but to move the viewer, it can be helpful to add some action. Our job as photographers is always to draw the viewer in so they linger longer on the image. Movement has the ability to grab attention and to hook your viewer.

Implied movement is when you add something to a scene so the viewer can then imagine the movement that will result. Visualize a bartender pouring a drink or a chef tossing a pizza in the air. Even though these are still images, freezing a moment in time, the brain can foresee the liquid splashing around inside the glass. The viewer's mind intimately understands gravity and knows that the tossed pizza will return back to the pizzaiolo's hands.

These implied movements can also be subtler. They can be small movements that don't require extra gear, special camera settings or an extra person to execute. This next challenge is exactly that.

+ CHALLENGE

Imagine you're frosting a cake. You pick the flavor. You made a bowlful of homemade Swiss meringue buttercream (my favorite!). Imagine the texture of the frosting, its sheen, how the light plays with the swirls and folds in the bowl. What happens next? You dip an offset spatula into the bowl and gather a scoop of frosting. Be sure you're allowing your creative mind to visualize this. It's the most delicious method of meditation. Then see yourself adding that hefty dollop of frosting to the top of an un-iced cake. Focus in on the dollop.

The next step is to spread the frosting with the spatula. Just as you've started that first swath, pushing frosting up under the spatula like a mounting wave . . . stop. Hold that pose, hold that movement, but don't follow through with the spread. Prop the spatula up on something outside the frame and just zero in on the place of action where the spatula is spreading the frosting. The path from where the spatula started is marked and the un-spread frosting lays ahead. The next movement is implied.

Now that you've imagined this scene, it's time to create your own image with implied movement. The subject matter is up to you. You can spread frosting on a cake like we did in the visualization or smear peanut butter on a sandwich. Or maybe you want to show pasta being tossed with a vibrant green pesto or a worn wooden spoon stirring a rich marinara sauce in a pot. Food is dynamic. Engage your imagination and make a moving image for your viewer.

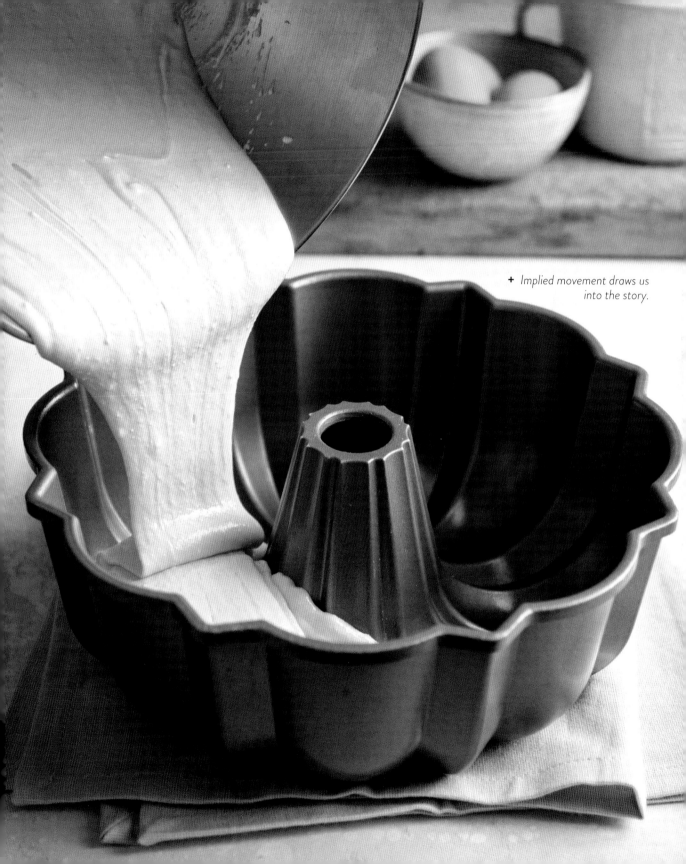

+ *Implied movement draws us into the story.*

16. BRING LIFE TO YOUR IMAGES
WITH A HUMAN ELEMENT

People are an important part of the story of food. **The people who make the ingredients, prepare the dish and enjoy the meal can all be potential subjects to incorporate as "the human element" in a food image.** They can be shown as hands at work, smiling eyes and frosting-smeared faces. But, as romantic as this notion sounds, humans also have the uncanny ability to look awkward or pull focus from the primary subject in an image. I have compiled a list of best practices I keep in mind whenever capturing myself or someone else as the human element in an image.

- Consider the best outfit to wear. If you're only adding a hand to the scene, wardrobe considerations aren't as crucial. But, sometimes it's helpful to add dimension and atmosphere to the story by incorporating more of the arm or torso. If you do, though, just like in considering what props will best complement your scene, clothing requires some forethought. Don't select items that will distract from your food, like busy patterns or bold colors. Think about the story and select clothing to complement it. I like linen and denim clothing and aprons with enough texture to add interest, but subtle enough to meld naturally with the theme.

- Beware the claw. Hands have a knack of looking odd in photos and can easily look like claws grasping pitchers of syrup or spoonfuls of sauce. I always approach holding an item with a soft grip and take a number of test shots with the hand in different positions to see where it looks most natural. You can also practice in a mirror so you can see how different grips and ways to hold the item look before taking any test shots.

- Get closer than you think you should. If you are pouring something, like maple syrup on pancakes, it always looks odd if you pour from too high. The most natural position for pouring is typically higher than what looks good in photos. This can cause the container or the hand to be out of the frame altogether. Test the height of where you need to pour from first before letting the syrup flow. You'll feel like you're pouring super close to the food, but I promise, it will create a more balanced composition.

- Mind the manicure. My manicurist loves to make fun of me for always selecting a natural-looking nail polish color. She's always pushing for something more vibrant, but I tell her that I need to keep it neutral for the photos. Particularly when shooting for clients, it's requested that the nails look clean and natural in order to not distract from the aesthetic or story of the image. That said, if the storyline of the image calls for bright red nails or bedazzled talons, then don't let me stop you. Stick with your vision and make your choices intentional.

- Shoot on a tripod. It's impossible to capture yourself in a photo without the use of a quality tripod to position your camera. You will also need a way to fire the shot without being behind the camera. This can include the use of self-timers, remote shutter devices or, depending on your camera, a wireless phone app to fire the shot.

- Don't block the light falling on the subject. The top priority in any photo is the light. It can be frustrating when you have the lighting just right, and then when

you introduce a human element, it blocks the light in unhelpful ways. The placement and position of the body and hands should never block the light from the subject. Practice placing them in the scene and double-check how the lighting looks. If you see that an arm, hand or torso is negatively impacting the lighting, experiment with other placements and positions. I personally like to position the body and the hand on the side of the scene opposite of the light source so as to remove the possibility of blocking the light.

· Mind your posture. Without fail, I always notice when I shoot with my body in the scene that I need to work on my posture. Sit or stand up straight.

+ CHALLENGE

Devise and capture a scene incorporating a human element. Think about the story and how the person relates to the food you're shooting. Is it a chef? Bartender? Grandma? Mom? Dad? Best friend? Experiment with placing the person (or yourself) in different positions at different angles and see how small adjustments can make a big impact on the overall image. Feel free to rehearse in a mirror before you get in front of the camera if you're photographing yourself.

Take plenty of test shots before capturing the final image. If you're like me, it might take thirty shots until you get one that looks good. After the shoot, evaluate what went well and what could have been improved. Jot down your notes, and take this first-hand learning with you into your next shoot.

17. THINK BIG WITH FAMILY-STYLE
DISHES AND LARGER SCENES

Think about your favorite foods. I love grasshopper pie, buffalo wings and Mom's Caesar salad, though not together or in that order. Each of these foods recalls a special memory and brings to mind time spent with friends and family.

One way to tell the story of a shared meal is to create a larger spread or to showcase a food served family style. Sometimes in food photography we can get locked into shooting a singular dish. Here's your opportunity to break out and create something bigger in scale and story.

Composing a larger scene can be tricky given the number of elements involved. The party on the opposite page, for example, has the entire cake, plates and napkins. It can be a little overwhelming to arrange so many items at the outset. My strategy in these situations is to **set the table as I would in real life**, arranging place settings where they would be if I was hosting a dinner party. You can take it a step further and also incorporate multiple people into the shot, keeping in mind the tips from the previous lesson.

I also think about the point of the meal this image is capturing. Is it before everyone is seated? Then things will be neatly arranged. Whereas if it's later in the meal, things won't be perfectly composed. Midway into the meal, the napkins will be rumpled, glassware will be half filled and tableware will be askew. Always return to the concept of the story and what you want your viewer to experience with the food being captured.

+ *Keep in mind the little details like the discarded candles and cake server in this party scene.*

+ CHALLENGE

Get out your notebook and think about a food that holds special memories for you. Maybe a favorite family dish or something you like to cook with friends. Think about sitting down with the people you associate with this dish and what it would look like if you were all together. What is their posture? What are they drinking? How far are you into the meal? What music is playing in the background? Is the table formal or informal? What is everyone discussing? Start making a list of everything that comes to mind. It can be single words and phrases. These notes will guide you through the process of selecting props and planning the shoot. Use these notes to create your final shot list. I almost always take the opportunity with large scenes to capture a wide-angle overhead shot as well as some close-up three-quarter angle detail shots. If you go through all the work to set up this shoot, you should make the most of it and get a variety of images.

If you want to incorporate human elements in the scene, you might need to grab a few other people to be your models. Heck, at this point, make it a dinner party and tell everyone to be prepared to have their picture taken. Finally, set up your large scene and capture the images on your shot list. But, please, don't photograph people while they're taking a bite of food. No one looks cute chewing. No one.

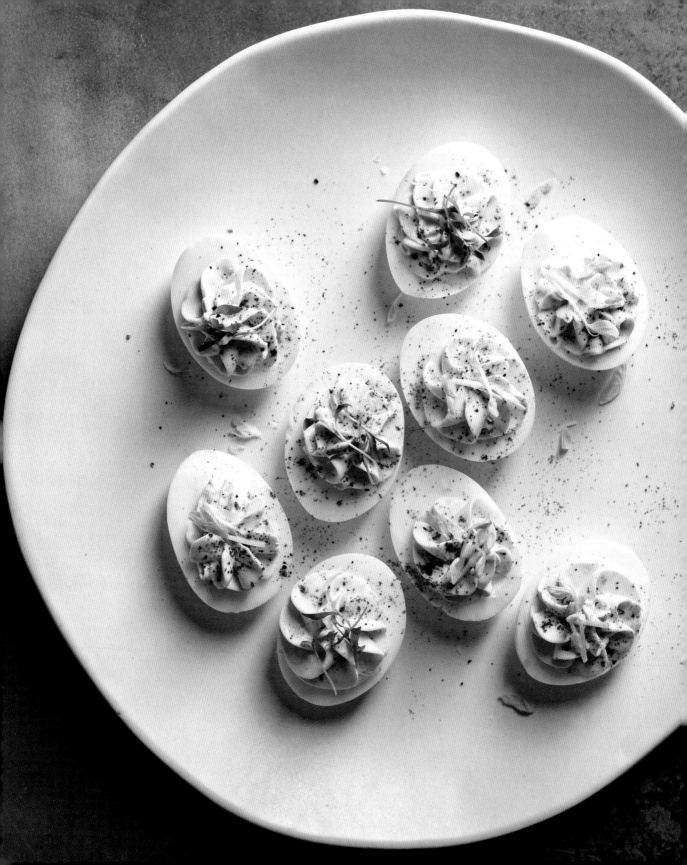

PROPS STYLING

Choosing the Right Supporting Subjects to Show Off Your Food

I was shopping for my first set of real dishes and my grandma, a woman with impeccable taste, advised me to ask an important question before choosing a set: "How would it look with an egg on it?" It seemed like an odd suggestion at the time, but years later, as I continue to expand my large props collection, I still imagine an egg on a plate before I purchase it. There was wisdom in this advice, acknowledging that the plate should suit the food, not the other way around. Flatware, drinkware, linens and backdrops should do the same. The lessons in this chapter will help you think about the visual elements in your scene that are inedible so you can make purposeful choices in styling a set.

18. BUILDING A PROPS COLLECTION
THAT FITS YOUR NEEDS

I remember the first time I worked with a stylist on a photoshoot. Ellen taught me so much. She had neatly stacked bins on a collapsible hand truck. She opened the first bin and there was a flash of colorful napkins, carefully folded. The next bin was full of bags of organized cutlery. Another bin with little dip and pinch bowls. Her on-the-go collection felt magical and was the start of my own journey of collecting props, and over the years, I've purchased many. Some are winners that I use frequently; others have eventually ended up at the secondhand store.

When considering props, it's important to evaluate what will best suit your needs. If you're a food blogger or content creator and looking to establish a signature style, you will likely be fine with a small selection of standard go-to items that complement your aesthetic and the kinds of foods you like to prepare. For my food blog, I cook a lot of casseroles, so I have a lovely 9 x 13–inch (23 x 33–cm), white, cast-iron casserole dish that shows off my favorite home-cooked recipes. I also have a set of gray speckled dishes that I use in nearly every shoot for my blog. They have a homey, organic feel to them that fits with my preferred style.

If you're creating for a variety of different clients or building a commercial photography business, you will need a wider range of props. But before you run out, thinking you need to amass a huge collection, it's worth researching if there are local props shops or props stylists in your area. **Larger cities generally have places where you can rent props and other items for your photoshoots so that you don't have to purchase and store them yourself.** Or, there might be other bloggers or photographers in your area who are willing to rent or lend their props to you.

But, if you are props obsessed and have the budget and space to store a large collection, please don't let me stop you. I shop for props in a variety of different places. You can find great basics at big box retailers that carry home good items like bakeware, cookware and dishware. I've found some of my favorite unique and well-worn props at antiques and secondhand stores and estate sales. But, by far, some of my favorite pieces are handmade ceramics that I found through word of mouth, social media and online searches. Generally handmade products are more expensive, but their character and visual quality justify the price, especially considering how often these pieces get used.

Regardless of whether you're renting props or building your own collection, these are frequently used staples in my personal collection:

- Neutral-colored ceramic plates and bowls. It helps to have a light set and a dark set so you can capture different moods.

- Matte or antiqued flatware. If I'm buying individual pieces instead of full sets, like at antiques stores, I like to get at least three of each piece so that if I'm capturing multiple dishes in one scene, I have at least one utensil per serving. Also, if you have a stack of flatware within the scene, odd numbers look a bit more visually balanced.

 + Some of my most loved and frequently used props

- Basic short drinking glasses. Sometimes your composition and story need a few drinks added, but regular drinking glasses can sometimes be too large and overwhelm the scene. I like simple, small glasses with a hint of detail for visual variety without causing distraction.

- Wine glasses. Along the same lines as the drinking glasses, particularly when working with fancy foods, wine glasses can be an elegant addition. I like having a set of stemless as well as ones with stems, both white and red, depending on what the food and composition require.

- A worn cutting board. Neutral-colored wood cutting boards that have been lovingly worn are a favorite for food photographers. You'll see my favorite board used throughout this book in various ways to add character, layers and framing to subjects. One suggestion is to be choosy when it comes to the color of the wood. Select something neutral that isn't too orange or yellow as these colors can distract from the food.

- Linen napkins. A few high-quality linen napkins are must-haves in my props collection. Higher-quality linen has a great weight to it, so that it falls nicely when it's folded, and it usually has a more interesting texture compared to something cheaper and more mass produced. My favorite go-to napkins are 22 x 22 inches (56 x 56 cm).

- Fabrics. In addition to napkins, other miscellaneous fabrics can come in handy. Tea towels, cheesecloth and tablecloths are popular options. I even have an old white canvas curtain that was hiding in our linen closet that I love to use. These fabrics can serve as the background or as a nice accent to the scene to add depth and texture.

The one guiding principle I always keep in mind with any prop I purchase is to evaluate if it will complement food. I love bold patterns and designs in my own home, but when it comes to food photography, the props should never upstage the food. The fire-engine red plates in my home kitchen are great for serving dinner, but they have yet to make it into my studio.

+ CHALLENGE

What is one thing you can do this week to improve your props collection or props options for future shoots? If you aren't planning to build your own props collection, research props rental options or start making connections with other local creatives who might have collections they're willing to rent or lend to you.

If you do have a collection, it can help to inventory and document your props. I photograph new props as I add them to my collection and post them in an online gallery that I can send to clients when planning shoots. It also helps me keep track of what I have and to avoid purchasing duplicates.

19. PICKING BACKGROUNDS AND
SURFACES TO ELEVATE YOUR SCENE

One of the most significant leaps forward in the look of my images was when I started to intentionally select the surfaces and backgrounds. **As a quick point of definition, surfaces refer in general to the tabletop on which you're shooting. Backgrounds are the vertical area behind your scene when shooting from a straight-on or three-quarter angle.**

When I first started my photography, I was shooting on the kitchen counter and dining-room table. The trouble is, unless you live in a home that looks like a magazine (I don't!), the countertops and surfaces most likely won't flatter your food. My dining-room table had an overwhelming orange hue. My countertops were dark and shiny, throwing tons of glare into the camera and, again, distracting from my subject.

The day that I realized food photographers were using dedicated surfaces and backgrounds for their images was a major aha moment. There are innumerable ways to get your hands on a flattering surface. As food photography continues to become more popular, there are online retailers who specialize in food photography backgrounds.

Printed vinyls are the most affordable option. I love vinyl for shooting on location because it's easily portable. However, these can sometimes tear or wrinkle after frequent use. Also, I find vinyls aren't the best for super close-up shots because the texture is printed and not the real deal. But for most standard overhead shots and images intended for online use, vinyls are my pick for something easy and affordable.

If you have the budget, there are companies that create textured and painted surfaces. They generally have expertise in food photography and understand important concepts like the appropriate level of texture to complement a scene and color theory. These surfaces are among the prized possessions in my studio.

You can also create your own surfaces at home. My tried-and-true method for creating a DIY backdrop is by applying joint compound (spackle from the hardware store) to a large piece of laminated plywood. Spread it all over with a joint knife and create some organic-looking texture. Allow it to dry for at least 24 hours once you've applied the texture you want. If you find that you went overboard on the texture factor, you can sand it down a bit. A little texture is helpful, but if there's too much, your plates won't lay flat.

Next, I paint the dried surface with matte paint. I suggest starting with more neutral colors and then working up to bolder hues over time. You can also combine different colors for a mottled look, and use sponges and rags to create interesting motifs and textures. After the paint is dry, and you're happy with your surface, seal it with a clear matte finishing spray to help protect it. It won't be fully stain resistant, but this will help preserve the color and texture you've applied.

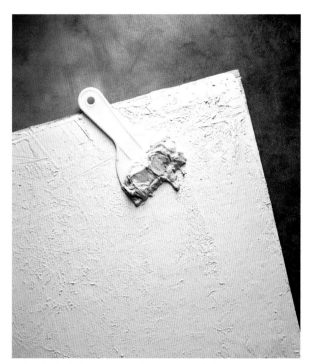

+ *Apply the joint compound to a sheet of plywood.*

+ *I used gray and white matte paint for this board.*

Paper is another affordable and easy option for shooting on. Parchment paper can add character and lend to the story of your image. I always have a roll of white parchment and brown parchment in the studio as a quick background solution. Crumple it up to add a little texture and visual interest. If you flip back to page 41 with the galette, you can see the parchment paper in action.

If you flip back to page 41 with the galette, you can see the parchment paper in action.

+ PRO TIP

When purchasing or making my own surfaces, I like to select a size that's at least 2 x 3 feet (61 x 91 cm). I find anything smaller can be limiting when framing the shot and composition.

+ CHALLENGE

Select a food to shoot and capture it on three different backgrounds. Observe how the backgrounds alter the image. Consider how the different colors and textures enhance or distract from the food. Does the background help tell your intended story or create an eyeball-grabbing aesthetic? Does it have enough visual interest and texture to be interesting without being distracting? Your background is the backbone of your image. Learn to select with intention.

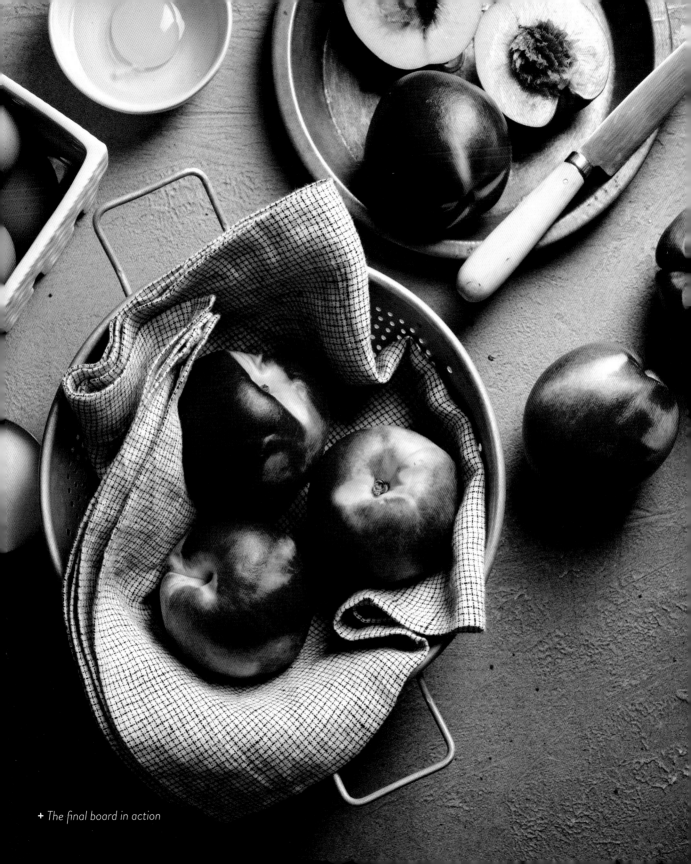

+ *The final board in action*

20. HOW TO SELECT PROPS
LIKE A STYLIST

I peruse my props collection before every shoot, and if necessary, do some props shopping. **Picking props that fit the story, character and colors of a scene is one of my favorite parts of the shot-planning process.**

Let's take these meringues on the next page for example. There are a lot of ways to capture meringues. I could show them being piped onto the parchment paper before being baked in the oven. They could be finished and on a cake plate ready to be served. I could show a single meringue on a napkin with a bite taken out of it. For this shot, I wanted the right-out-of-the-oven feel, so I captured them on a baking sheet on parchment paper. But, that's not just any baking sheet. I have multiple baking sheets to choose from depending on the story I'm telling. I have a pristine, clean sheet for something more sleek and modern. You can see in the photo I used the well-worn one that reminds me of my mom's kitchen. It tells the story of homemade treats being prepared for friends. I love how it adds texture and visual interest.

I keep both brown and white parchment paper on hand because color is important as we've previously discussed. For these meringues, since they're white, the brown paper provides a nice contrast.

You can see some additional incidentals in the image, too. They're not intended to be the focus but can help to support the composition and story. When selecting incidentals, I put them through the same questions I ask of the primary props in the image. Do they support the story being told? Do they make sense in the context of the image? Are their colors supporting the color mood and theme but also not distracting? Do they contribute to a sense of balance?

Once I have selected some props that I think will work well, I have fun arranging and taking test shots of them on the surface I plan to use. This is a chance to experiment with composition and assess if the props are working well together. But this is also the stage in the process where you have to be a bit ruthless.

Sometimes you'll have a prop that you are so excited about and want to use, but when you start taking test shots, it becomes clear it's not going to be the best fit. Perhaps the color is too bold, the pattern is too busy or it's the wrong size. I have been in situations where I forced a prop to work and ultimately wasn't pleased with the final image. Whether you're going for a minimalist or maximalist approach in your styling, make sure that the additions support the story and help drive the viewers' eyes to your subject.

+ PRO TIP

When I come across props in other photographers' images that I love, I will reach out and ask where they purchased a particular piece. This is also why I love to tag and share where I find my props in my social media posts.

+ *Meringues from the oven, dusted with powdered sugar*

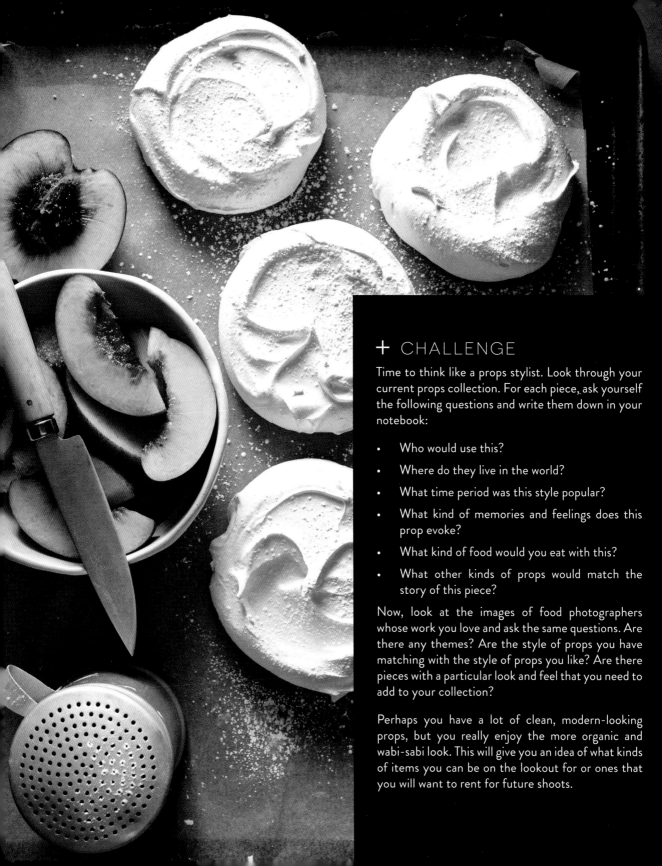

+ CHALLENGE

Time to think like a props stylist. Look through your current props collection. For each piece, ask yourself the following questions and write them down in your notebook:

- Who would use this?

- Where do they live in the world?

- What time period was this style popular?

- What kind of memories and feelings does this prop evoke?

- What kind of food would you eat with this?

- What other kinds of props would match the story of this piece?

Now, look at the images of food photographers whose work you love and ask the same questions. Are there any themes? Are the style of props you have matching with the style of props you like? Are there pieces with a particular look and feel that you need to add to your collection?

Perhaps you have a lot of clean, modern-looking props, but you really enjoy the more organic and wabi-sabi look. This will give you an idea of what kinds of items you can be on the lookout for or ones that you will want to rent for future shoots.

21. HOW WELL DO YOU KNOW
TABLE ETIQUETTE?

Have you ever had etiquette lessons? Some would say it's a dying art, but it's still relevant in props styling. The selection and placement of tableware within an image is generally based more on the aesthetic of the image and composition. **However, it is still important to be aware of the proper application for different kinds of flatware, glassware and dishware.**

I was on a cookbook shoot once, and we were setting up to capture a bowl of soup. The art director asked if we had any options for soupspoons. Luckily, I knew that soupspoons have a wider and deeper bowl compared to teaspoons and dessert spoons and showed her several options for the shot. These same nuances apply when working in fine dining restaurants where it's expected that the right flatware is present and that it's placed in the proper position relative to the food.

There are also cultural considerations for tableware. I learned when shooting for a Japanese restaurant that chopsticks should never be displayed crossed because that is a symbol for death.

It's hard to keep track of all the applications and rules around tableware, so take the time to research the specifics of what you'll be working with before any shoot. For example, if you're shooting oysters, be aware of what tableware might be paired with oysters and the proper use and placement of those items. Knowing your dessert fork from your dinner fork will come in handy and set you apart as a professional in food photography. Of course, don't be afraid to ask questions in the moment if you're not familiar with something. It's better to ask for help than to make an embarrassing mistake.

+ CHALLENGE

This is a research opportunity. Read through the following list and mark the tableware items you know and feel confident about how they're used. Write down in your notebook any of the items that are unfamiliar. Take the opportunity to research them. This list is not exhaustive of all potential tableware you might come across, but it will send you down some helpful rabbit holes for your own learning.

- ramekin
- soup plate
- coupe bowl
- tablespoon
- teaspoon
- citrus spoon
- demitasse spoon
- dessert spoon
- cocktail fork
- olive fork
- salad fork
- dinner fork
- dessert fork
- joint fork
- butter knife
- dinner knife
- cheese knife
- butter pick

- pasta server
- tomato server
- cake breaker
- pilsner glass
- pint glass
- goblet
- collins glass
- highball
- rocks glass
- Irish coffee mug
- Bordeaux glass
- burgundy glass
- coupe glass
- flute glass
- tulip glass
- cordial glass

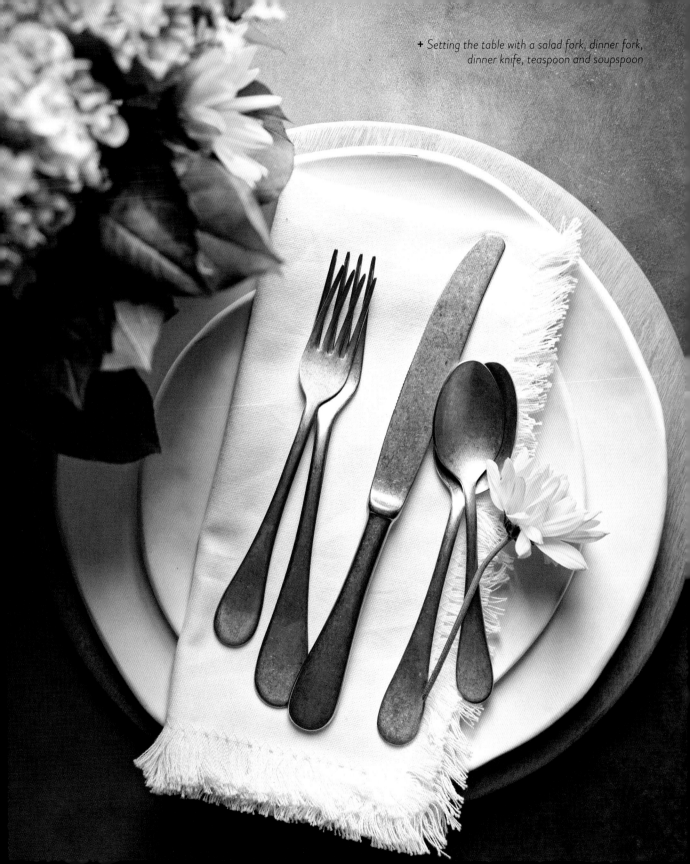

+ Setting the table with a salad fork, dinner fork, dinner knife, teaspoon and soupspoon

22. TIPS FOR STYLING NAPKINS
THAT LOOK NATURALLY PLACED

If they haven't already, napkins will, at some point, cause you major frustration. I often lament that years of my life have been lost to messing around with napkins. It's hard to get them to look like they're naturally integrated into the scene, supporting the subject without being a distraction. So many times, when introducing a napkin to a scene, it doesn't want to lay the way I see it in my mind's eye. I have compiled a list of strategies that make working with napkins a little easier because, ultimately, they can add a lot to the scene and are worth wrestling with to include in our images.

- Spritz them to add pliability. Adding a little spritz of water to a cloth napkin can help when it won't sit quite right. My favorite is to use a fine mist spray bottle so it doesn't leave water spots on the napkin.

- Refold the napkin. If the napkin looks a little too perfect and rigid, I'll open it up and unfold it, and then refold it the opposite way. That helps loosen it up and add a little dimension if the napkin was sitting too flat.

- Use it like you would in real life. Like I mentioned in the lesson about styling large scenes (page 55), one of my favorite strategies with props is to set the scene like I would an actual table. So, if I want to tuck a napkin under a casserole dish that came out of the oven, I'll actually use the napkin to lift and set the casserole into the scene so it falls more naturally like it would in real life. This can add to the storytelling of the scene and make the placement look more realistic.

- Look for the experts. There are stylists and photographers out there who are napkin wizards. I have taken a lot of inspiration in how to fold and place napkins from others who do it well. Dive back into the magazines and cookbooks you love and assess the napkin use. Take note of smart napkin applications you can keep in mind for future shoots.

- Don't wash the napkins. I find that napkins lose a little bit of their structure and they don't lay as nicely after washing them. I'm very careful to keep my napkins and linens clean when using them in my scenes so they don't get stained. If I do get something on them, I'll use a wet sponge to clean them up.

+ CHALLENGE

Forget the food for this challenge. This is simply an opportunity to play and exercise your napkin styling skills. Select a napkin and a plate and experiment with placing the napkin with the plate and take a test shot to see how they look together. Does the napkin lay naturally? Does it need to be adjusted? Fold and refold. Unfold. Try the napkin in different spots in different configurations. Continue to take test shots. Always ask, "Is this adding to the scene and supporting the focus on the subject or is it causing a distraction?" Repeat the process with different napkins and find out if some of the napkins you have are easier to work with than others. If you're like me, you'll end up with a handful of favorites. I have tons of napkins, but there are a half dozen that are my most used because they are easy to manipulate and photograph nicely. Throughout the week, when you photograph food, push yourself to incorporate a napkin into every shot and to find new strategies and methods that make working with napkins easier for you.

+ *A simple, folded white linen napkin adds character and texture to this scene.*

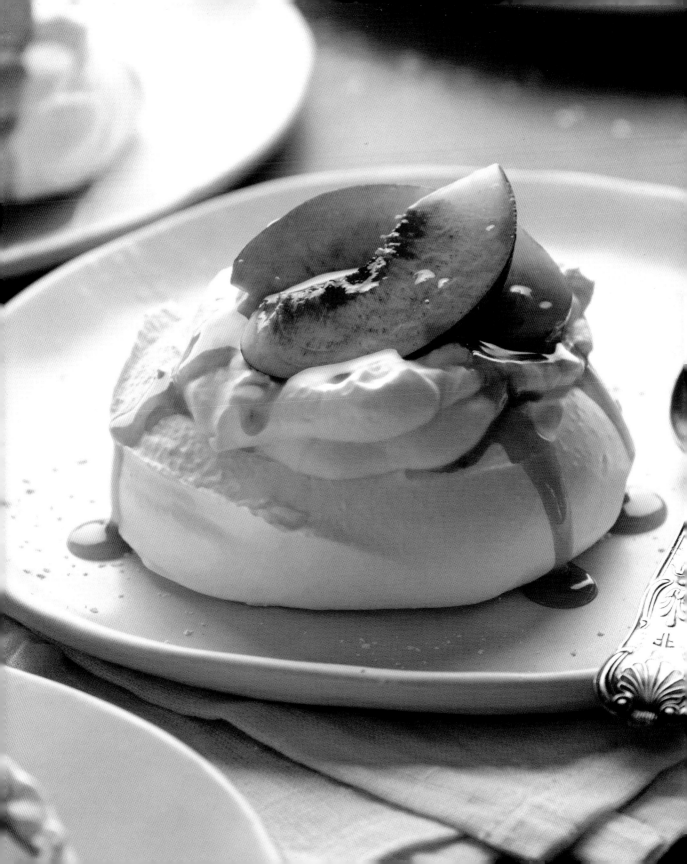

COMPOSITION

Arranging the Elements within the Frame for
Maximum Visual Impact

Have you ever set up a scene and found yourself rearranging everything multiple times over because something about the way you've placed the items feels "off?" Creating a composition—arranging elements within the frame—is an art. Let's continue our food photography journey by exploring the foundational principles of composition in art and design to make our images easier on the eyes.

23. FINDING VISUAL REFERENCES
TO EXPAND YOUR INSPIRATION

No one creates images out of thin air. When we set to the task of planning a shot, our brains are subconsciously running through a visual library of what we've been exposed to in our lifetime: art in museums, album covers from our childhood, the wallpaper in your aunt's house, books, movies, cartoons, packaging, social media images, cookbooks, websites. We live in a visually driven world. All of these visual inputs have an impact on how we create. That's why I'm constantly taking in new inspiration from a wide variety of sources and building my visual fluency.

As we explore the principles of composition, I have found the best quality references specific to food photography are in cookbooks and food magazines. Images in these kinds of publications are created by professional photographers and stylists with intentional art direction. **As you're developing your critical eye, you'll start to analyze how images are constructed.** These subtle observations will make their way into your creative brain and inform the decisions you make behind the camera.

For example, early on in my food photography journey, I found myself captivated by an image of a bowl of granola in a magazine. What I loved most is that it was captured from a low angle so that just a little bit of the granola and fruit topping were peeking out from above the lip of the bowl, as if I were a child peeking up with eyes just above the table to catch a glimpse of the food inside: a literal sneak peek. I've since taken this visual reference and infused it into my own work when I have the opportunity. See how I applied this compositional technique to the image of the eggs on page 49.

I subscribe to a variety of magazines and am continually adding to my cookbook collection in order to expand my visual reference points so that when I sit down to create, my brain has a greater library from which to find inspiration.

+ CHALLENGE

Schedule a time this week to add to your visual reference library. You can take yourself on a date to your local bookstore or supermarket where food magazines are sold. Or hop online and research the digital magazines your local library has available. Browse through the pages of the different publications, and allow yourself to drink in some inspiration. If you're like me, there will be some magazines that you gravitate toward and will find more visually stimulating than others. This is a good thing and indicates something about your own preferred sense of style. If there are images you find particularly moving or publications that you find inspiring, treat yourself and buy a few select magazines to add to your collection. Perhaps even purchase a subscription; I love it when the ones I subscribe to arrive in the mail.

You can also create inspiration boards on Pinterest with your favorite images of food. I like to organize mine based on different kinds of dishes for quick-and-easy reference in the future. If you have a Pinterest board of cookie images, the next time you shoot cookies, you can quickly jog your memory.

24. SELECTING A PRIMARY SUBJECT
TO STAND OUT

The goal in photography is to draw the viewer into the frame, take them directly to the subject and then convince them to stay a while and explore the rest of the scene. This is accomplished through thoughtful composition, the art of arranging items within the frame. It sounds simple, but it's perhaps one of the most difficult aspects of photography and can make or break an image.

The first place people tend to trip up when setting up a composition is in failing to designate a primary subject. It can be easy to lose sight of where we want the viewers' eyes to land first. Sometimes additional supporting subjects are added in such a way that causes distraction from the primary subject. I'm not saying you shouldn't add props to your images. With proper composition techniques applied, you can have a jam-packed frame that still directs the eyes straight to your subject upon first glance. But the key and very first step in creating a composition is to select your primary subject. Designate it so you know where the focus is to be placed.

Perhaps this sounds obvious, but I have seen many food photographers, myself included, add multiple things to a scene, wanting to give them all equal airtime and importance. Like the shots of oatmeal with berries on the next two pages. In the first composition, based on size, positioning, color and lighting, both the berries and the oatmeal carry equal importance and compete for attention. This is where you have to choose. Which subject is more important? They can both be in the scene, but a single, primary subject has to be selected so that the viewer has a single point of entry into the image, and then they can meander throughout the frame to enjoy the supporting elements.

The second image has been slightly modified so that the viewers' eyes see the oatmeal as more important. The next several sections will dive deeper into the tools we can use to help support our primary subject, but it all starts with making the choice. What's the most important item in the frame, and where do we want our viewer to look first?

+ CHALLENGE

Select three or more food photos of your own, and ask yourself these questions about the composition of each image:

- Is it clear which item is the primary subject in this image?

- Does your eye go immediately to a spot in the image, and is that spot the most important in terms of the scene and the story?

- Is there anything in the scene competing with your primary subject, overtaking it, pulling focus? Why is it distracting? Is it the color? The visual interest? The brightness of it in comparison to your intended subject?

Select one of these images where you find there is opportunity to improve upon the composition and reshoot it with this lesson in mind. As you are setting up the composition, ask yourself, "What is the primary subject, and how can I help make it stand out?"

+ Which subject is more important? It's hard to choose between the bowl of berries and the bowl of oatmeal.

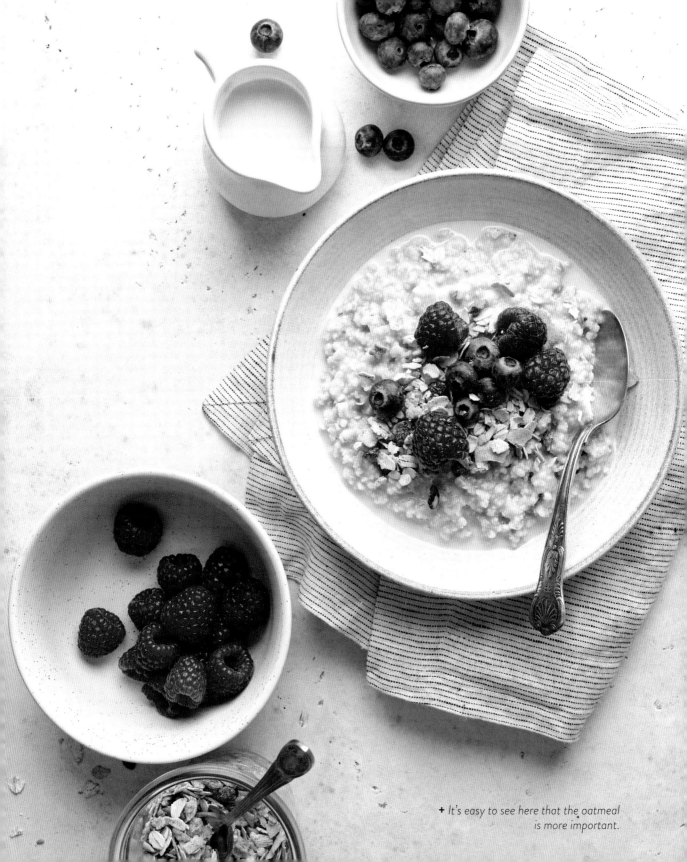

+ *It's easy to see here that the oatmeal*
is more important.

25. CONSTRUCTING AN EFFECTIVE IMAGE
WITH CONTRAST

A powerful tool we have for driving eyeballs to our primary subject is applying contrast. To be clear, I'm not referring to the contrast slider in your editing software, though that can certainly help. **I'm talking about the larger concept of creating opportunities for contrast, such as juxtaposition or putting two visually different things next to one another to draw attention.**

Think about opposites in the visual world: light vs. shadow, color vs. black and white, rough vs. smooth, shiny vs. dull, straight vs. irregular, in focus vs. out of focus, crowded vs. isolated. Contrast is one of our greatest tools whether you have a lot going on in an image or if you are taking more of a minimalist approach. When we can find opportunities to put our primary subject in contrast with what's around it, that will help direct the viewers' eyes where to look.

For example, in the image of oats on page 93, why is the eye pulled to the toppings first? Because they are more colorful than anything else in the scene and carry the most visual interest. The background (the bowl, the spoon, the napkin and everything else) is more muted, but the berries and muesli jump out at us in contrast.

Similarly, the photo of berries on the next page plays on the idea of contrast with the interruption of a pattern. The eyes are drawn directly to the blueberries because they are different—a contrast in the midst of all the containers of red berries.

On page 40, the viewer is drawn immediately to the galette because it's the brightest part of the image contrasting with the rest of the scene falling into darkness. Conversely, on page 19, the coffee pulls our attention first because it's the darkest spot in the image in contrast with the otherwise lighter-toned scene.

If you keep opposites on the brain, and you have determined your primary subject, you're well on your way to more effectively composed images that will be easy for your viewer to understand and appreciate at first glance.

+ CHALLENGE

Open up a food magazine or cookbook and start thumbing through the images. If you don't have magazines or cookbooks to draw from, do an image search online. Select three images that you find visually attractive. For each image, ask these questions and write down notes about their use of contrast:

· Where is my eye drawn to first?

· Why is that spot eye-catching? In what way is that spot in contrast with the rest of the scene or the area immediately surrounding it? Is it brighter than the rest of the scene? Darker? More colorful? More textured? More in focus? Interrupting a pattern?

· Could the photographer have incorporated another element of contrast to further drive the eyes to the focal point?

This exercise will help you see contrast so that when you're setting your own scenes in upcoming challenges, you can see opportunities in your mind's eye where contrast can be incorporated to support your subject. Continue to be mindful of contrasts and juxtaposition as you come across images throughout this week. If you find any that are particularly strong or demonstrate contrast in a way that speaks to you, bookmark or pin those for future reference.

+ *Notice the interruption of the pattern.*

26. BRINGING BALANCE TO YOUR SHOTS
WITH VISUAL WEIGHT

When you look at this image of oatmeal, does it feel balanced, or is there imbalance? There is purpose and value in both depending on how you want the viewer to feel. Do you want to invite them into something comfortable and familiar—something easy on the eyes? Then you'll want to create balance in your composition. But, if you want to add some tension, maybe make the viewer uncomfortable (and yes, there are images where that's important), imbalance will be the tool. For the most part, in food photography, we are inviting the viewer to enjoy the food, so balance is our goal.

How do you create balance? Visual weight. Every item you place within a scene carries visual weight. Imagine there's an invisible line down the center of the frame and in order for the image to feel balanced, there has to be equal weight on both sides of the line. This can be achieved by creating a symmetrical composition where the two sides are a mirror image. But if you want some variety and dynamic energy you can mix things up as long as you keep the visual weight in check. **The most common factors that determine the visual weight of an object in comparison to another object are its relative size, color, brightness and location within the frame.**

+ *Does this image feel balanced or imbalanced?*

Items that are physically larger carry more visual weight compared to smaller items, such as the bowl of oatmeal in comparison to the smaller bowls of toppings. The one large bowl on the left is counterbalanced with the multiple smaller bowls on the right side. The weights visually balance to the center.

Items that are more colorful or vibrant carry more visual weight compared to neutral tones. You can see the napkin is placed to the left, but because it's neutral-toned, it's not as heavy and doesn't throw off the balance achieved with the smaller, colorful items on the right.

Similarly, lighter-toned objects carry less visual weight compared to darker objects. If you had a piece of paper and drew a white circle on the left and a dark circle on the right, both equal in size and symmetrical in position, the dark circle would feel heavier and the composition would feel weighted toward the right.

Additionally, the object's position within the frame determines balance. Gravity is always in play in our minds, so objects at the top of the frame feel heavier than objects at the bottom. When they're higher, we see the force of gravity bearing down on them. Lower in the frame, they are still and at rest. This happens even when we are viewing the scene overhead and the items are static. So, even though the bowl of oatmeal and the napkin are physically larger in size, the positioning of the ingredient bowls higher in the frame creates counterbalance along with their vibrant color. It's like a seesaw.

However, **these scales shouldn't be looked at as an absolute formula.** Composition, like art, shouldn't be mechanical or too calculated, but having an eye on balance can be a helpful guiding principle.

+ CHALLENGE

Go back to your favorite food magazines or cookbooks or hop online and do an image search to find three images that jump out at you. Go for ones that catch your eye quickly and draw you in immediately. For each image, ask yourself:

- Does this image feel balanced? Why or why not?

- Is there something that would help it feel more balanced?

- If I added one more thing to this image, what would it be and where would it be placed to maintain balance?

- If I took away one thing in this image, what would need to be changed in order to rebalance the image?

Continue to train your eye by looking at images you come across during the week and ask these same questions. Develop your critical thinking and attention to the concept of visual weight. Your creative eye is continuing to get stronger as you deconstruct more and more images. These skills will be helpful as we dive into the upcoming challenges that require you to craft your own images.

27. USING LINES AND SHAPES
FOR IMAGES THAT ARE EASY ON THE EYES

Effective imagery makes use of the most basic tools of visual communication: lines and shapes. Let's go back to elementary school and talk about squares, triangles, circles and lines. Our brains are hardwired to look for these basic shapes in images to help organize and make sense of what we're seeing. As you know, attention spans are short, so quick information processing is paramount. This doesn't mean I'm asking you to draw literal shapes and lines in your images. Instead, **consider how similar items within your image connect to one another to create shapes and lines, like an elevated form of connect the dots**.

Take, for example, the smoothie images on the next page. We see them all in a row in the first image, creating a horizontal line across the image. They are all the same shape and form, so our eyes see them as connected and interpret that as a strong horizontal line across the frame. That line is supported by the lines created by the additional ingredients surrounding the glasses.

Lines, in addition to helping organize our images, have the ability to support our story, and the manner in which you place your lines can add feeling and emotion to the image. Horizontal lines communicate balance and calm as they, like the ground we walk on, are solid and unmoving. They are like our bodies when we are lying down . . . in a state of rest. Vertical lines are powerful and strong, and even, at times, aggressive. They have fought gravity and are positioned at attention, standing up, sometimes even soaring. Diagonal lines communicate movement, action and stimulation. Like a runner positioned at the starting line, diagonal lines are poised to move. They indicate forward or backward momentum depending on the orientation of the diagonal and its relationship with the direction in which you read script. Those who read from left to right across the page will see a diagonal stretching from the lower left of the frame to the upper right as a forward movement and the opposite diagonal as backward movement. Those who read from right to left, like in Arabic and Hebrew languages, will see the forward-moving line as the one stretching from the lower right to the upper left of the frame.

Curved lines are also an option and are used to communicate elegance and grace. An s-curve is a popular composition technique, where the composition follows an s-shaped line. Thumbing through the pages of this book, do you see any s-curve compositions?

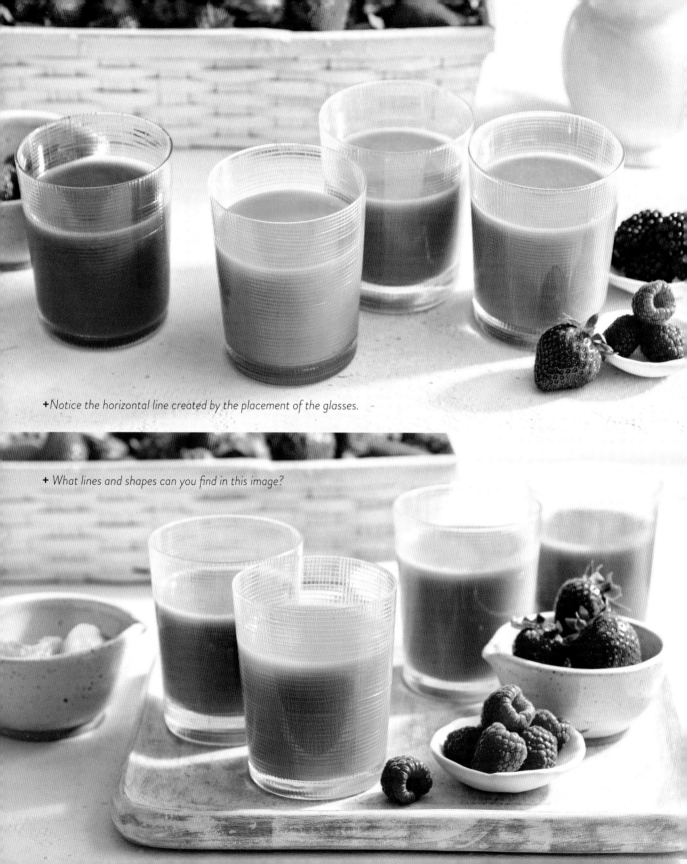

+Notice the horizontal line created by the placement of the glasses.

+ What lines and shapes can you find in this image?

As you create lines in your images, consider these subconscious messages and how they connect with the story you're telling. If you're presenting an image of health and wellbeing with organic juices, perhaps a horizontal line or an s-curve will be most fitting. An over-the-top chocolate-lover's dessert, on the other hand, might call for a strong vertical composition.

In the second smoothie image on the opposite page, additional props have been introduced. Do you see the shapes they form in relationship to one another? The cutting board is a square and creates a frame around the primary smoothie. The ingredients in the small bowls are configured in such a way to create a triangle that further reinforces this framing. The same applies when we place food on a round plate, which is a distinct advantage we have in food photography. The circle of the plate sends a signal to the viewer to "look here!"

One of the challenges you will find in this art of creating shapes and lines is that there is a balance to strike in terms of creating lines within the image that are apparent, yet at the same time, naturally integrated. **Scene styling and composition can start to look staged and forced.** So, as you place items with intention, feel free to add some imperfection. Mess things up just a bit. For example, going back to the first smoothie image, there are gaps between the glasses so that it looks like they might actually have been naturally placed on the countertop. And the ingredients are not perfectly lined up and rigid. A little bit of undoing can help to avoid the scene feeling overly staged.

Any time there are items within an image that are similar in shape, size, color or visual interest, our brains will connect the dots and create invisible lines. If these dots are connected in such a manner that creates balance and harmony while helping to draw lines to and frame our subject, chances are we're on the path to creating a strong visual image that communicates its purpose clearly and quickly.

+ CHALLENGE

Let's play connect the dots! Get out your notebook and the food photos you've collected in prior exercises. Select three images for this challenge. For each image, answer the following:

· What is the predominant line(s) present in the image?

· What kind of energy and feeling does the line imply?

· Does this use of line match with the visual story being told?

· What shapes are formed in the image?

· How do these shapes help direct the viewers' eyes to the subject?

· What does the use of these shapes imply about the story?

Now that you're seeing shapes in these images, you'll start noticing them in other photos, too! My apologies in advance if you're no longer able to simply enjoy photos and begin to overanalyze them. If this is happening, you are well on your way to stronger compositions through the process of building your visual reference points. You likely already have a subconscious sense of creating line and shape in your images, but now, armed with this knowledge, you can more efficiently and effectively compose a scene. This will be helpful as you create your own compositions in upcoming challenges.

28. APPLYING COLOR AS A TOOL
IN COMPOSITION

Earlier we explored the concepts of color in terms of hue, value and saturation. Now it's time to take those concepts one step further and understand how we can use them as tools in composition.

Like subjects within the scene, colors hold different visual weights. For example, red is a heavy color. Blue, in comparison to red, isn't as heavy. If you have blue and red together in a composition, you might need to add a greater quantity of blue within the frame to balance out the presence of red to create harmony. A deep yellow would be heavier than pale pink. A saturated teal would be heavier than a light amber. Consider the proportions of colors present in an image, how they interact with one another and how they create harmony or disharmony in your image. Looking at the image of the four smoothies on page 82, does one color possess more visual weight than the others? If one of the pink smoothies was orange instead, how would that affect the visual weight and the position of the drinks?

Also, remember that colors are an additional way to create lines and shapes within an image. You can have two things that are different sizes and forms, but if they are the same color, the viewer's brain will create a relationship between the two items.

Considering the temperature of your colors can also help inform creative choices. Cool colors like green, blue and purple recede backward into the frame whereas warm colors like red, orange and yellow advance forward toward the viewer. Knowing that, if you have a subject that is a warm color—like an orange or magenta smoothie—it is more likely to carry more weight and jump forward off the page in contrast to a cooler blue background. If, instead, it was a cool-toned purple smoothie like the one to the right, it could get lost receding backward if it were placed on an electric orange background. Instead, that same smoothie really pops on a less-saturated, soft orange wood background.

+ CHALLENGE

Select five paper swatches from the challenge in Lesson #13 (page 46). Order the swatches from heaviest to lightest in terms of visual weight. Repeat this exercise several times with different swatches in different hues. Tackle an all-red palette ranging from pink to crimson. Play with a blue palette from navy to powder blue. Also experiment with a rainbow-colored assortment. This is yet another exercise in training your eyes. Being able to see the visual weight of colors and how they differ will help in making more informed decisions when it comes to backgrounds, props and styling. As with the previous color challenge, this might be a frustrating exercise because interpreting color is subjective, but the more time you spend wrestling with color, the deeper your understanding of it will be.

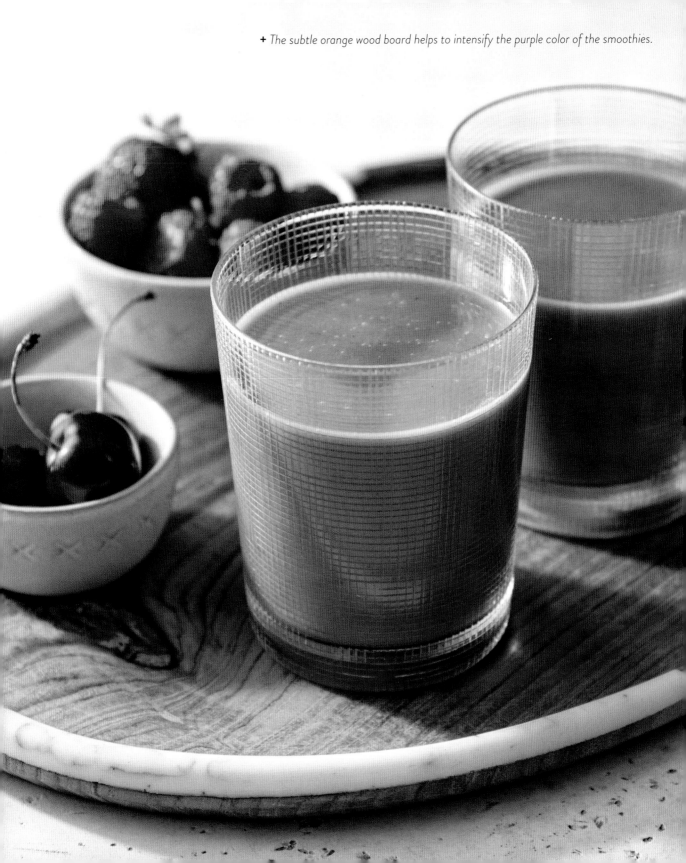

29. SHOOTING FLAT LAY
FOR A BEAUTIFUL BIRD'S-EYE VIEW

If you have spent any amount of time online, you'll know that food shot from overhead (also referred to as flat lay) is very popular. It's the bird's-eye view and can be the ideal way to show off different kinds of dishes whose visual interest is overhead. Soups and salads, pastas, pies and pizzas are excellent flat lay subjects because their best assets can be seen from above. Despite the popularity of this perspective, there are some pitfalls to keep in mind.

First, before opting to shoot food overhead, consider if that angle is going to work well for that given subject. For example, for sandwiches and burgers in particular, their most visually interesting components are seen from the side when they're on the plate. All you see is the top of the bun from the overhead position. However, I have seen some creative photographers turn burgers on their sides and stack them in such a way that they can be captured well as a flat lay. **Make sure to take a moment in planning your shot to think about where the visual interest lies in your selected subject and if that's able to be captured from above.**

Second, consider the direction the light enters the scene and how it contributes to the feeling of balance in the image. Put yourself in the shoes of the viewer. If the scene was truly being viewed in real life, the viewer's body would be blocking the light entering from the bottom of the frame. Because of this, it feels much more natural for light to enter from the top or the side of the frame with shadows casting downward or to the side. If you see a flat lay image that feels out of balance, check from which direction the light is entering the frame. This isn't a hard and fast rule, but it's something I often find helps contribute to a sense of harmony in a flat lay image.

Finally, another aspect to consider as you're composing your overhead scene is incorporating layers to create a feeling of depth. For example, add a napkin under a bowl peeking out from the sides, and then place a spoon on top of the napkin. You can add in a glass filled with ice and sparkling water or a vase with flowers. I like to challenge myself to consider ways to add more layers to an image, especially in flat lays. For example, the udon pictured to the right shows seven layers at different levels: surface, napkin, chopsticks, bowl, broth, noodles and ingredients, and garnish. The peripheral items won't be the central focus, but the depth of layers tells the viewer's brain that this image is more than a flat two-dimensional image. It's a three-dimensional peek into a world you've created.

+ CHALLENGE

Time to break out the cookbooks and food magazines again! Find an image that has been captured from the overhead angle. Study it, taking special note of how the food is positioned to show off visual interest. Look at the direction from which the light enters the frame and how the shadows are cast. Also, count how many layers were built into the scene and how that contributes to a feeling of depth. Take notes and continue to assess overhead images as you encounter them throughout the week.

Armed with this newfound flat lay knowledge and what you've learned about composition thus far, plan and capture your own overhead food photo this week. Will you go for ramen, pepperoni pizza or a charcuterie board? There are a lot of options, so pick something that speaks to you.

30. SHOOTING STRAIGHT ON
FOR A FEELING THAT'S MONUMENTAL

Sandwiches, burgers, parfaits, cakes, baked goods and drinks are all excellent subjects for the straight-on, head-on perspective. It's the idea that we are shooting directly at our subject to get the ultimate view of the side of the food, to the point where sometimes the top of the food isn't visible. This approach has the ability to make the food look monumental. Depending on how low you go, it can even feel a bit dramatic because of the vertical nature of the composition. Remember, vertical lines communicate strength and power.

There are three things I always keep in mind when shooting straight on. First, I pay attention to the light, ensuring that the light is properly illuminating the front side of the subject. **At the head-on angle, the majority of what is visible is the front side of the subject, so if the light's not hitting that area, we'll miss the details and the interest of the subject.** For most head-on shots, I utilize side light that rakes across the front of the food, revealing its texture. Each subject and creative vision will be unique, so there is not a one-size-fits-all lighting setup for shooting straight on. What is important is to pay attention. See where the light is hitting your subject, how it's showing off the texture and details, and adjust as necessary to make the most of the subject.

Second, don't forget gravity. Like we covered in Lesson #26 (page 78) on visual weight, it's the force that affects everyone and also translates to how we experience images. In the real world, the horizon is horizontal, a straight line from the left side of the frame to the right. The viewer experiences a greater sense of balance and visual harmony if the horizon in your image is level. Of course, plenty of filmmakers such as Alfred Hitchcock have opted for a slight tilt in their camera angles along the x-axis, creating a feeling of tension and suspense. This is referred to as the Dutch angle and is a powerful device. But, for the most part, our food photography isn't intended to put audiences on the edge of their seats, so we stick with level horizons.

Finally, also in consideration of that horizon line, I am mindful about where it intersects with my subject to avoid creating tangents. **Tangents are when lines and shapes within a composition are touching or intersect in ways that are visually bothersome.** Such as, if the line of the horizon overlaps with the top of a straight line of a subject. It can cause the two to fuse visually in an awkward way. I like to adjust the perspective so that the horizon intersects somewhere within the middle area of the subject or so that the horizon passes above or below the subject. You can see this illustrated in the BLT images on the next few pages. The first image is composed so that the line intersects near the middle of the sandwich. This helps to differentiate the background and the subject. In the second example, the horizon intersects with the top of the sandwich, creating a tangent that diminishes the separation and power of the subject.

As you start to develop your critical eye, you'll notice that advertising images frequently make use of the head-on perspective. It's bold, dominating and sometimes even aggressive. The straight-on angle can be a powerful device for the right food.

+ PRO TIP

Be thoughtful about the plate you select when shooting food head on. Deep plates with a significant lip can block the lower portion of your food, which might not be desirable. I prefer to shoot head-on images with flat-lipped plates.

+ *The horizon line
intersects near the
middle of the sandwich.*

+ CHALLENGE

Choose a food that is well suited to be captured head on. It could be a sandwich, a cake, a loaf of bread or a drink. Choose something that gets you excited. Keep in mind the tips from this lesson and possibly do a little reading ahead to the next lesson, too. It's easy to miss the difference between the straight-on angle and the three-quarter angle. Once you feel confident in your vision for your selected food, set up and shoot a straight-on image. Then, send that image to three friends and copy and paste this message with it:

Hi, I'm completing an assignment to improve my food photography, and I need your help. Look at the picture I have created of [fill-in-the-blank]. Imagine that this [fill-in-the-blank] had a personality. What three words would you use to describe its personality or attitude? The only word you can't use is "delicious."

The feedback from your friends might be wildly different or strikingly similar. Chances are, if you have created a true straight-on angle shot, some of the words they will share might relate to strength, power, dominance or even aggressiveness depending on the subject matter and styling. You don't need to limit this experiment to this type of shot, either. Try it with other images. You might see themes emerge that give an indication of your unique style and storytelling methods.

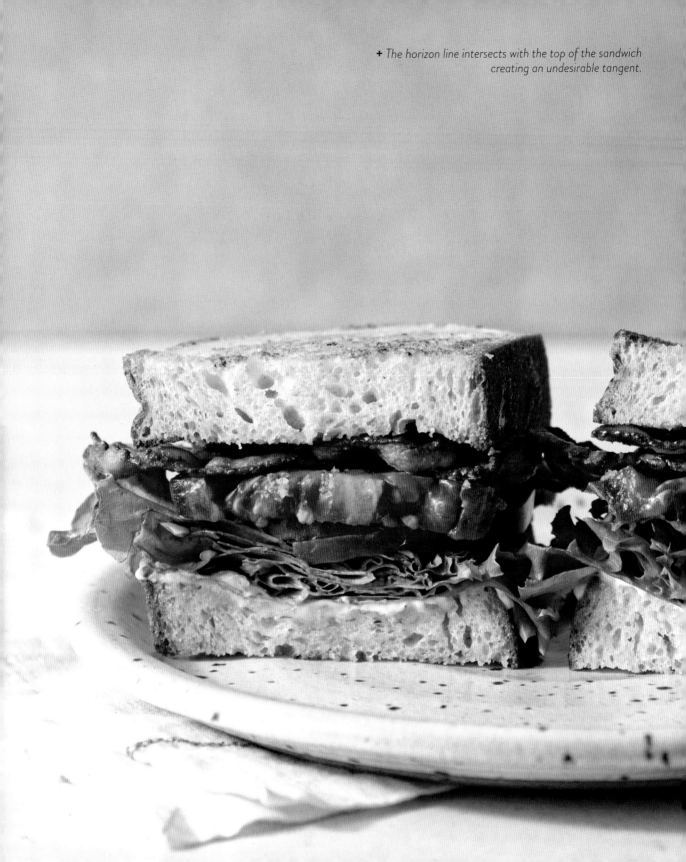

+ *The horizon line intersects with the top of the sandwich creating an undesirable tangent.*

31. NAVIGATING THE THREE-QUARTER SHOT
TO FIND THE BEST ANGLE FOR YOUR FOOD

It's referred to as the three-quarter shot because three-quarters of your subject is visible. The top, sides and front are all visible from this approach, so in that regard, this can be the best angle for shooting food. It maximizes how much the viewer sees of the subject.

The question that always comes up, however, is how do I know how high or low I should position my camera? The famous photographer's answer is: It depends. **The three-quarter angle is typically captured with the camera positioned somewhere between a 30-degree and a 70-degree angle from the table surface.** The challenge is that there isn't a one-size-fits-all angle for the three-quarter angle that works for every dish. Some food looks better from a slightly higher angle to show off more of the top of it. So, in that case, get closer to 70 degrees. But sometimes, there is more interest in the food on the side of it, in which case, a lower angle, closer to 30 degrees, will be more fitting. If you take it lower than 30 degrees, you're venturing into the head-on angle.

Another consideration is whether or not you want the background to be visible. Sometimes I have a great surface, but I'm in a location where the background isn't appealing. Or perhaps I don't want a visible seam in the back of my scene. In these cases, a higher angle of approach can eliminate the background or seam altogether to simplify the composition. This is what I've done with the oatmeal image on the next page.

I see a lot of people go wrong with this angle by losing sight of the sense of gravity in the image. As we talked about in Lesson #30 (page 88), the horizon line contributes to the sense of balance. Sometimes, when shooting from three-quarters, the horizon isn't visible within the image. However, the scene should still be composed as if the horizon were visible—as if it's straight across from the left to the right side of the scene. That means the base of our plates should be flat and level. Otherwise, it feels like we're stepping into an unbalanced and potentially unnerving environment. Perhaps your image's intent is to create a sense of imbalance, in which case, shoot with a tilt in the perspective. But, if you are looking to achieve harmony and a true-to-life vision, don't forget to keep your horizon level, even if it's outside the frame.

+ CHALLENGE

Select any subject and experiment shooting it at a variety of angles ranging from a 30-degree angle, moving upward into 45 degrees, and then to 60 degrees. Assess the images and critically consider which angle was most effective for that subject. Was it better from a higher angle that showed off more of the top? Or was the side stronger and a lower angle preferable? Is the horizon straight? How has the angle affected what's visible in terms of the environment and background? Asking these questions and critically considering your angle of approach will strengthen your eye the next time you tackle another subject from this angle.

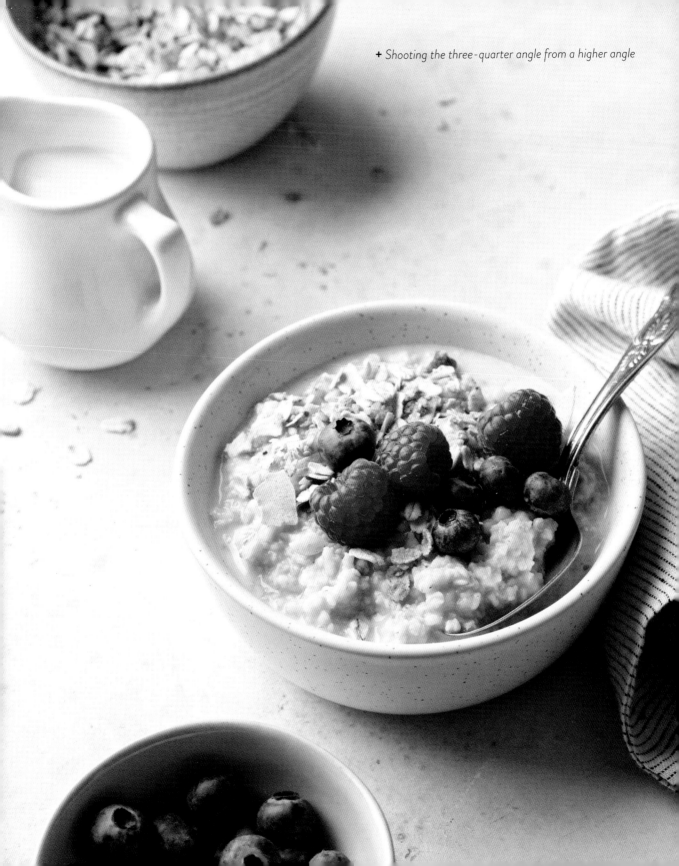

+ Shooting the three-quarter angle from a higher angle

32. MAKING SCENES
BELIEVABLE WITH
FOREGROUND SUBJECTS

One of my goals in my food photography is for my scenes to look convincing. I don't want things to feel too staged. The exception to this rule is advertising product photography, which is meant to look staged. But, for most of the editorial style work that I do, I want the viewer to think that they're seeing something that could happen in real life. This can be challenging because most of the images I create are carefully crafted scenes. If I want something to appear within the frame, I have to put it there.

That's why I pay special attention to the foreground of my scene as an area that can help support the believability factor. The foreground is the area in front of the primary subject, the area of the image that is physically closest to the viewer. **The foreground is powerful because elements placed there can help frame the primary subject, give context to the scene, add to the storytelling clues and provide a feeling of depth.**

The scattered ingredients, the napkin under the front of the plate and the small dish all appear within the foreground of the image below. You can see that they are not the primary focus and are serving in a supporting role. But by having them near the front of the scene, it creates the sense in the viewer's eyes that they have happened upon this scene, peering past what's closest to them to take in the lovely layers of the udon soup. Creative use of the foreground is a powerful tool that can help turn a staged scene into an image that transports your viewer.

+ CHALLENGE
Turn back to the magazines and cookbooks and find an image that does a great job of incorporating supporting elements in the foreground. You might find that these are hard to find. But when you find one that you like, craft an image that recreates the way in which they added to the foreground. Maybe it's an out-of-focus branch peeking in through the top side of the frame. Perhaps the lip of a plate peeks into the foreground . . . or some sprinkled sea salt. Take note of how the foreground was used effectively, and capture a scene with that technique applied.

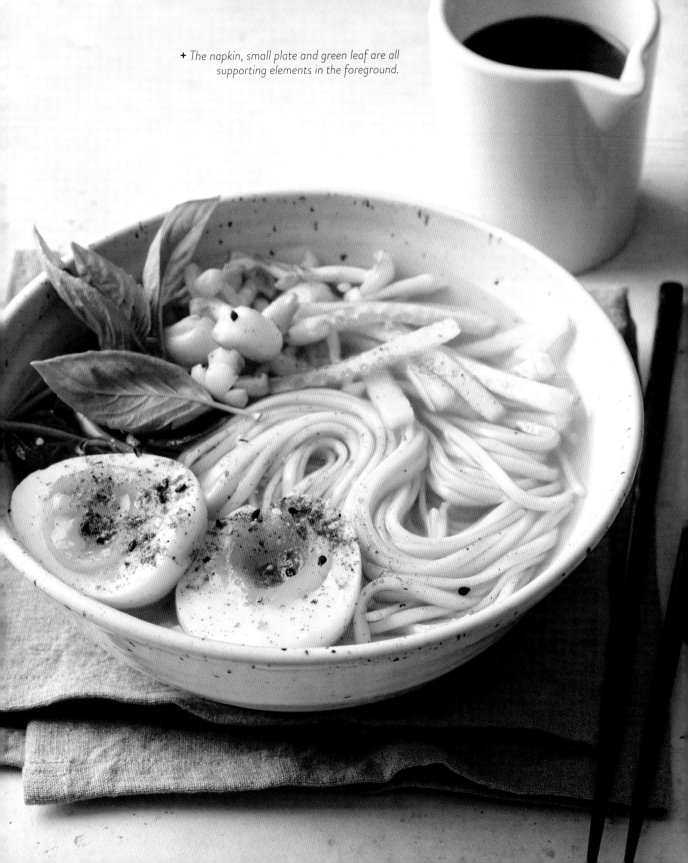

+ *The napkin, small plate and green leaf are all supporting elements in the foreground.*

33. HOW TO USE NEGATIVE SPACE
AS A SUBJECT

Many times, I've found myself asking, "What else should I add to this scene?" I scan my props shelves, thinking that I need to add more to the shot to make it special. The truth is, some of my favorite images showcase the philosophy that less is more and are elevated through the use of negative space.

Negative space is essentially any area within the frame that's empty. It's the space that surrounds the subjects in the scene. If you densely fill the frame with the subject and props, there is likely not much negative space. But, if you leave some open space—some room within the frame—and create that space with intention, it can serve to strengthen the overall composition.

The primary thing I keep in mind when it comes to negative space is that it becomes a subject in itself. Negative space holds form and shape and thus the same considerations apply to negative space as do with any subjects in the scene. In the image of the peanut butter and honey sandwich on the opposite page (a Simon family favorite at lunchtime!), you will see there is a counterbalance of the negative space on the left and right sides of the frame in terms of size and position. See how the concept of visual weight continues to return time and again?

The same goes for creating lines and shapes with the connected nature of negative space. In the second image, see how the negative spaces form curved vertical lines that frame the central slices of bread and add movement to the image. Our eye connects these negative spaces based on their similar shape and form and color. Negative space is a powerful tool to help shape your composition. Just because a space is blank doesn't mean it's empty.

+ CHALLENGE

Create a composition where at least half of the space in the frame is negative space. This can be one large negative space or it can be broken up into smaller sections of negative space. Remember to keep balance, visual weight, line and form in mind as you craft your composition.

+ *See the counterbalance of the negative space on the left and right sides of the frame?*

+ *Negative spaces here form curved lines that frame the subject.*

34. PLANNING THE ORIENTATION AND
ASPECT RATIO FOR STRONGER SHOTS

It's important to know the orientation and aspect ratio you need to shoot when you're planning a shot. For example, when I shoot for my Instagram feed, I shoot the image vertically, meaning the longer edge of the image is on the sides and the shorter edge is on the top and bottom. I also know that Instagram can accommodate the 4:5 aspect ratio, with the shorter edge representing the 4 and the longer edge representing the 5. Most cameras in their basic settings will capture images in a 2:3 aspect ratio, which means the image needs to be cropped in the editing process to turn it into a 4:5. Consequently, some areas of the 2:3 image will be cut off when I crop it to 4:5.

The easiest way to understand this is to go into your editing software, like Adobe Lightroom or VSCO on your phone, and look for the crop settings. You will likely see preset options for different aspect ratios like 4:5, 1:1 (that's a square) and 9:16. The images in this book were cropped to the 8.15:9.25 aspect ratio because that's how the final images are displayed. Load any photo from your own photo collection in the editing software, select the crop tool and see how the different aspect ratios crop your image.

Knowing before you start shooting that the image will be cropped will help you better compose the shot in anticipation for cropping later. After all, you don't want to put something important in an area of the shot that will be eventually cut off. For this reason, I will also typically shoot wider than I need so that I have flexibility when I get to the cropping stage.

Much of our digital world calls for vertical images due to the vertical orientation of our phones. This has caused a lot of food photographers to more frequently shoot in the vertical orientation. Like anything, the more you do something, the stronger that muscle becomes. But if you're not also exercising the muscle of shooting images in the horizontal orientation, you might find it awkward or more challenging. In the same way that you exercise both arms when you do weight training, exercise shooting in both orientations and for different aspect ratios.

+ PRO TIP

Many phone shooting apps and tethered shooting apps for your DSLR and mirrorless cameras also have the option for an overlay guide that shows you an outline on the screen of where the crop will be so you can more effectively compose the scene.

+ CHALLENGE

Set up a scene and a subject, and capture it both in the vertical and horizontal orientations. See which feels more natural. Is one orientation easier for you? Were you able to compose the scene quicker shooting vertical or horizontal? If there's one that you find much more challenging, make sure to spend time in upcoming shoots to intentionally shoot that orientation, even if it's not a part of your shot list. Take time to practice it to build up your creative muscles for that style of composition.

35. PUTTING IDEAS ON PAPER
TO SAVE TIME ON SET

Have you ever set up a food photo where you put in all the work to cook the food, prepare the set, set up the camera, style the food and take the picture, only to rearrange the composition for an hour? Perhaps that has happened while going through the lessons and challenges in this book. At a certain point in the shoot, the food is past its prime, and you're left frustrated. If that's the case, that's a good thing because it means you're learning. If you're not struggling, you're not growing.

I find the best way to save time during a shoot is to sketch the scene ahead of time. Before I start any food photography shoot, before I get out my camera, before I start cooking . . . heck, before I even go to the grocery store, I get out my notebook and spend time imagining my scene and sketching ideas. I take into account the storytelling aspects of the image, the angle of the shot, the styling and props selections. If I'm shooting multiple images, I make several sketches to match my shot list. I consider the colors, the visual weight of different items, the orientation, the lines and the shapes. This helps me work out more fully in my mind how I want to set things up and to problem solve the composition ahead of time.

The final image might not exactly resemble the sketch because you never fully know how something will look until it is on set. But sketching helps you clarify your vision and do some composition problem solving before you have your hero dish in front of the camera, ready to capture. The sketch should be seen as a helpful rough draft, a way to get your ideas onto paper before setting to the task of creating your final image.

+ CHALLENGE

Get out your notebook and pencil. It's time to put your ideas on paper. Pick a recipe, a drink, an ingredient . . . anything you want to capture, and sketch out your scene. Take into account everything we have covered so far in terms of composition. Be sure you use pencil, because chances are that as you place subjects within the scene, you might start to move them as you add more. Also, feel free to fill up multiple pages of ideas and allow the planning process to build with each sketch. You will find that your own rhythm and workflow will evolve over time.

There's no right or wrong way to sketch, and don't get hung up on making your sketches pretty. They just need to be functional and get your creative mind working. Once you feel you have a good sense of your scene, use your sketches to capture an image or a series of images. After the shoot, reflect on the ways that the sketches were helpful. Was your final image similar to your sketch, or did the composition change drastically? Were there things that you would do differently with your sketches next time? Take those lessons and continue to improve upon your own preplanning process.

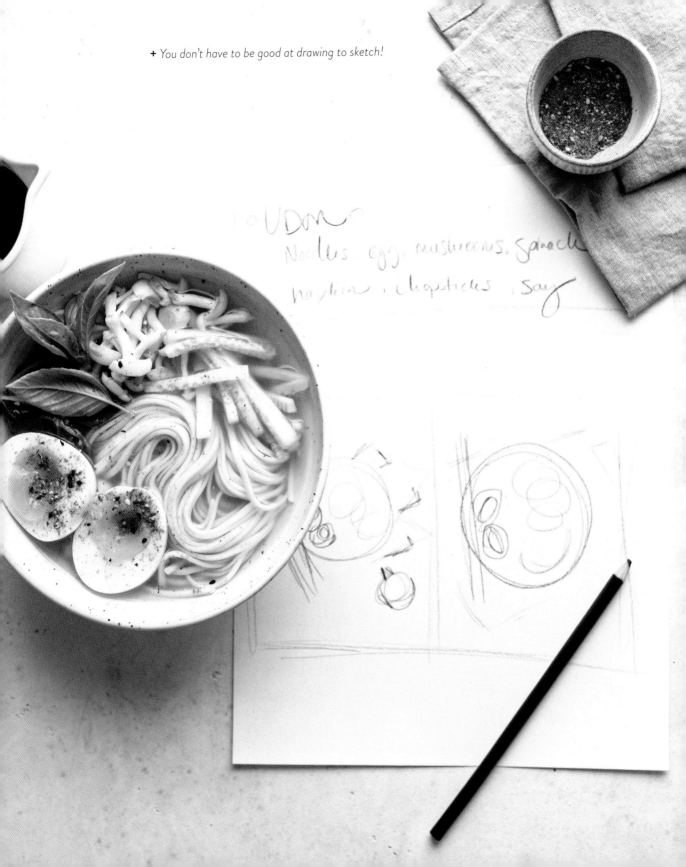

+ *You don't have to be good at drawing to sketch!*

UDON
Noodles, egg, mushrooms, spinach
napkin, chopsticks, soy

FOOD STYLING

Making Your Food Photo-Ready

You can have lovely, flattering lighting, a meaningful story and an intentional composition, but the real icing on the cake is working with food that looks good enough to eat. In case you came here for the industry tricks on how to make mashed potatoes look like ice cream or motor oil look like maple syrup, I'm afraid you'll be disappointed, because my tricks all involve real food. There's a time and place for the fake stuff, but the current and continuing trend is to work with the real thing. C'mon, let's play with our food!

36. RECIPE-TESTING STRATEGIES
TO PREVENT ISSUES DURING PHOTOSHOOTS

Several years ago, I received a job offer from a large confectionary brand. The shoot required me to bake their premade cookie dough into cups by forming them in a muffin tin. The images would include ice cream being scooped into these cute cookie cups. The idea was wonderful on paper, but when I tested the cookie cup recipe a week prior to the shoot, I ended up with a mess on my hands. The bakers out there know that in order to get dough to hold its shape when baked, it needs to have a very particular combination of ingredients. Premade commercial cookie doughs are made with oils and notoriously spread when they bake. So, to recreate the concept was impossible with the client's product. I shared the bad news with them, and they ultimately opted for an easier ice-cream sandwich concept. But, the important part of the scenario I want you to remember is that **it's imperative to test recipes before you shoot them.**

Hopefully, the future recipes you're going to shoot aren't doomed to fail like my cookie cups, but there are always unique things that you'll discover when cooking a recipe that will help set you up for success on shoot day. I recently tested a recipe for a salmon en papillote with cherry tomatoes and green beans. I used two different colors of tomatoes, some halved and some whole, to see which looked better after cooking. I also made one recipe with brown parchment paper and another with white. I ultimately decided the sliced red cherry tomatoes and the white parchment paper looked best and that was what I used in the final shoot.

Feeling confident about your recipe and how it's supposed to look and leaving as little to chance as possible are two of the best things you can do to prepare for your photoshoot.

+ CHALLENGE

Select a recipe to prepare for a photoshoot and do a test run. Good news! You can eat it right away since you won't be photographing this version. Throughout the cooking process, take notes about important steps and modifications you will want to make so that this dish looks its best when you do the actual shoot. You can also experiment with alternative methods to see if it visually improves a dish. For example, if you're baking salted caramel brownies, experiment to see if flake salt or coarse grain salt sprinkled on top gives you a better visual effect. Take these notes, and then create your photographable version of the recipe. Cook it, shoot it and share it using #pictureperfectfood.

37. TRIED-AND-TRUE STYLING TOOLS
OF THE TRADE

Food stylists are a crafty bunch and are known for their creative solutions. They are the behind-the-scenes magicians who know how to perfectly melt cheese and can wield the maximum glisten on a burger patty. Whether you're working with a pro food stylist on a shoot or you're doing your own food styling at home, **I highly recommend picking up a few of the key tools of the trade**. These are my top seven favorites:

- Museum putty: This stuff keeps everything in place. I use this way more than any other food styling tool in my arsenal. It's removable and reusable. You can find it hiding on the underside of a spoon resting on the side of a bowl when the spoon doesn't sit exactly where I want it. I stick it on the underside of round bottles when shooting a flat lay in order to keep them from rolling around. I also like to add a little underneath a cutting board to keep it from shifting around the scene. If you need something to stick, pull out the putty.

- Makeup wedges: Sometimes food needs a little lift, a little something to make it tilt just the right way for the light to catch it. I recently had a salad to shoot with a seared fillet of salmon on top. I was shooting it from a three-quarter angle, and everything looked great . . . except the salmon felt a little flat. It needed to be lifted in the back just a bit so that the beautiful crispy skin could be seen. I grabbed a makeup wedge and tucked it just under the back edge of the salmon for a quick and easy fix. You can see that behind my monumental BLT (page 107) I used makeup wedges to prop up the top half of the sandwich so that it would sit up straight for the final image on page 89.

- Funnel: Working with any sort of liquids or drinks will call for the use of a funnel. When you pour a drink into a glass, a funnel will help direct the liquid down into the glass and prevent splashing. It's also helpful for intentionally applying sauces or anything else that's apt to splash and make a mess of your set.

- Craft knife: Sharp knives are a must in any kitchen, but sometimes you need something small and extremely precise to get a clean cut. I use an X-Acto brand craft knife to cut the crust on a slice of pie to ensure it comes out clean. It works great for cutting into a casserole before extracting the perfect piece. It also comes in handy when cutting parchment paper to a specific size or any time you need to cut something that scissors can't handle. Along the same lines, quality scissors are helpful to have as well.

- Heat gun: This one comes with a warning. Please don't use this to blow-dry your hair. Though a heat gun looks similar to a blow-dryer, the important point of differentiation is that it can reach up to 1,100°F (593°C). They are typically used for stripping paint, shrink-wrapping and softening adhesives. You can get one at your local hardware store. I love having one in the studio for melting cheese, toasting buns and any time I need to apply some quick heat to a specific spot. Do be careful, as these are hot and a potential fire hazard if used improperly.

+ Tools of the styling trade

- Toothpicks and T-pins: If you lift the bun off a burger on set, you'll see at least a pin or two (more like ten). It's nice to have reinforcement to keep things from sliding around when constructing certain subjects like burgers and sandwiches. Have an avocado that wants to start sliding around on your BLTA sandwich? Stick a T-pin in it, and then keep on building that mile-high Dagwood.

- Tweezers: Most likely you already know about the importance of tweezers for moving things around while on set. They're helpful when microgreens need a little tweak or you need to extract a stray onion straw on a burger. Like most things in photography, there are opinions about which are the best. Some prefer smaller tweezers found in drugstores for health and beauty use. Other people prefer culinary tweezers, which you can find at restaurant supply stores or online. I personally use a 12-inch (30-cm) set of stainless steel culinary tweezers, also referred to as fine tongs. The devil is in the details, and the details are best managed with exacting tweezers.

+ CHALLENGE

Start building your food styling tool kit. Even if you're going to be working with a stylist, it helps to have these essential tools on hand. Additionally, network with other food photographers and stylists, and ask them what they think are the essential tools in their toolkit. Before you know it, you'll have a tacklebox full of food styling tools and will be ready for any jobs that come your way.

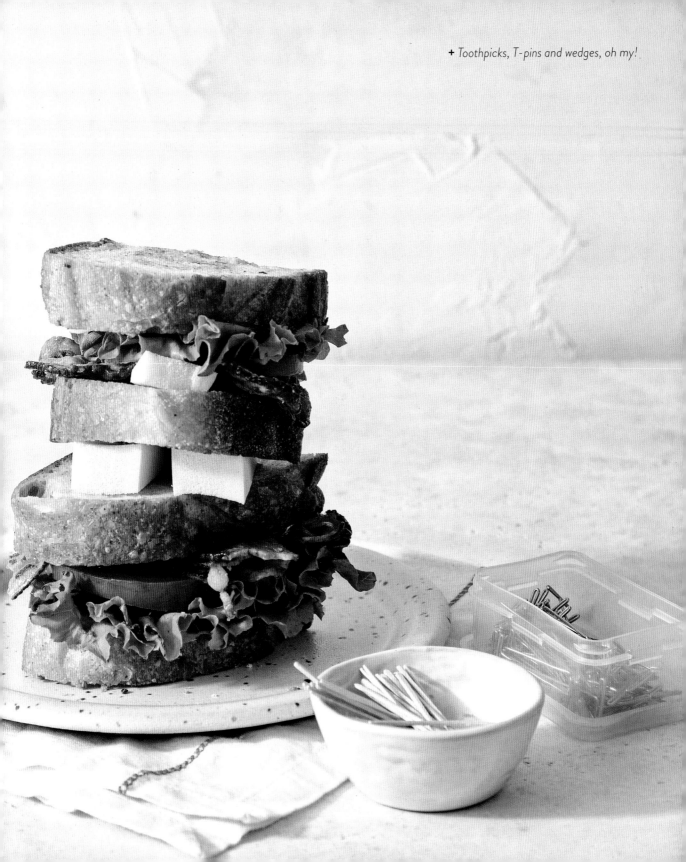

38. HOW TO SHOP FOR
QUALITY INGREDIENTS
FOR FABULOUS FINAL DISHES

Chances are, if you're passionate about food photography, you are also passionate about food. And if you love food, you know that great dishes start with quality ingredients. The same applies to food photography. **If you want a salad to look fresh, you can't be working with wilted lettuce and overripe tomatoes.** If you're capturing a holiday-worthy rack of lamb, make sure it's prepared with a proper French trim.

I like to shop for any perishable items the day before the shoot. Any sooner than that and you run the risk of the food not being its freshest. I also have my favorite places to shop. One store has the best produce, another has better seafood, and yet another has a better selection of breads. That means sometimes, depending on the shoot, I might visit several different stores to get what I need. I mentioned that the devil is in the details, right?

If I'm working with an ingredient or a dish that I don't know a lot about, I'll take time to research it before doing any shopping. I recently had a shoot that required guavas, so I went online to better understand the different varieties of guavas, what they should look like when they're ripe and how to prepare them. I also knew that I wouldn't be able to find them at my local supermarket, so I called around to two different specialty grocers to see if they had any in stock. Unfortunately, they didn't have any. Finally, I called a friend who works for a specialty produce company, and they were able to ship me the red guavas I needed. When it comes to sourcing quality ingredients, it's helpful to have connections.

+ CHALLENGE

Time to make some friends! Over the years, I have come to rely on people like my friend at the produce company to source quality ingredients. I know the butcher at my local specialty foods store who has helped me special order things like whole fish and seafood. I know local farmers and purveyors who I can call when I need something out of the ordinary. I am also always seeking out new connections, networking at my local farmers' market and chatting up the team members behind the counter at my local grocery stores. Your challenge is to make a new friend this week. Visit your local farmers' market or talk to someone behind the specialty counter at your local grocery store. You can also connect with a local purveyor on social media. There are so many ways to make new friends in food, but it all starts with you reaching out.

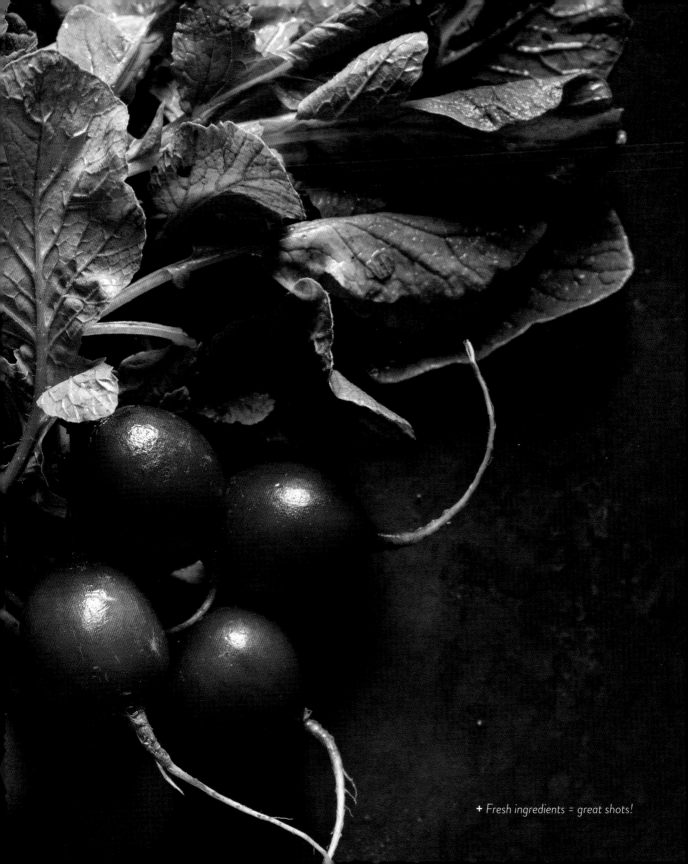

+ Fresh ingredients = great shots!

39. WORKING WITH STUNT DOUBLES
TO MAKE COMPOSING YOUR SCENES EASIER

The best lesson I've picked up from working with professional food stylists is to always have a test version of your food as you set up your scene. My friend and renowned food stylist Suzy Eaton calls it the stunt double. You can plan a shot and have the concept all worked out in your head with sketches ready to go, but until the food is on set, you won't know exactly how it will look. **But you don't want to put the final hero into the shot without knowing for certain that the lighting, propping, colors and all of the details are going to work.**

Imagine having an ice cream sundae that you've fully styled, complete with the cherry on top, only to discover once you put it in the scene that the props don't work at all and you want to use a different background. In the process of changing out the set, the ice cream will melt and you will have to recreate the sundae.

Instead, create a quick dummy version that's good enough to play with while you tweak the details of your set. As long as the color, size and shape are similar to your hero food, it will give you a chance to experiment ahead of time. Like the tacos on the opposite page, the dummy version was far from perfect, but it was good enough to compose the scene. I tested it out on different plates and in different arrangements without having to worry about it looking dried out and wilted. The stunt double allows you to have fun while you test your shot. It also ensures that you will be able to capture that picture-perfect shot of the food looking its best once the final hero is introduced.

+ CHALLENGE

Select a food to shoot, but before getting to the final plating, play with a stunt-double version. I typically make a quick, imperfect version of the dish with the real ingredients as the stunt double for items that don't require much cooking, such as sandwiches, salads and drinks. If I'm planning to shoot something that's a bit more complex or requires extensive cooking, like a large family-style dish, casserole, roast meats, cakes and pies, I'll use the dish that I plan to serve the food in. And I'll make a stunt double with something nonfood that's roughly the same size and shape. I have used rolled-up napkins, bottles and paper as stand ins. Another option for these kinds of foods is to use the recipe test version as a stand in. The goal is to be able to lock in all of the details before introducing your perfected, styled final dish.

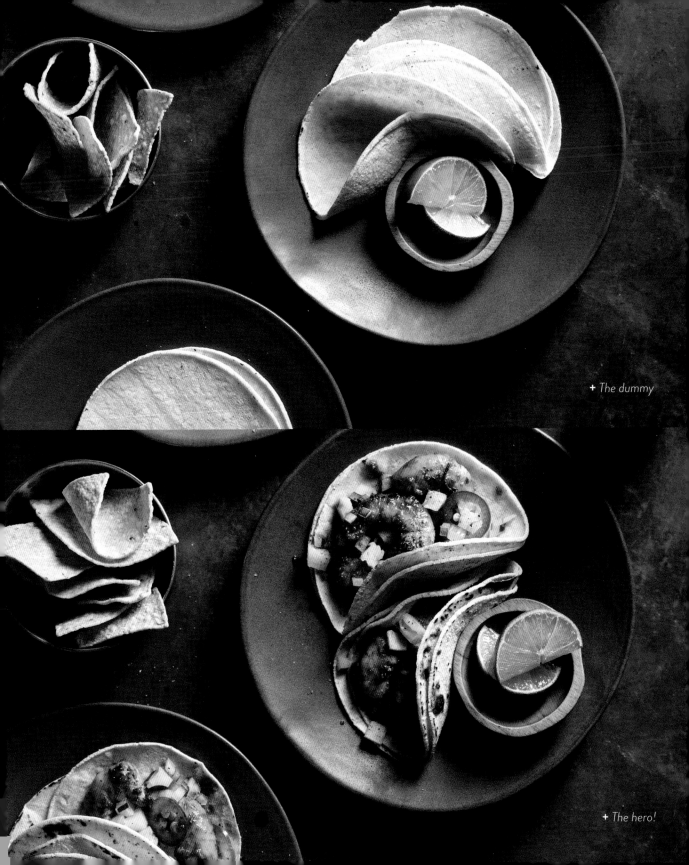

+ The dummy

+ The hero!

40. USING GORGEOUS GARNISHES
FOR THE ULTIMATE FINAL TOUCH

I am a stickler for a good-looking garnish. It's a small detail, but it can add so much in terms of color, texture, layers and visual interest. **Garnishes represent a wide array of additions to our food including herbs, spices, fruits and vegetables.** There is a lot to know when selecting and using different garnishes. Here are the questions I ask myself and keep in mind when considering this essential food photography element:

- Are there different varieties of this garnish? Which one will look the best or be most appropriate to this scene? For example, curly vs. flat-leaf parsley. Green figs vs. purple figs. Red peppercorns vs. black peppercorns.

- What is this garnish supposed to look like at its freshest and ripest? This is key for herbs especially and is the reason I like to grow my own herbs so that they retain their freshness and don't wilt as quickly on set. If I need an herb that I don't have in my garden and the ones at the grocery store don't look great, I will visit the local plant nursery or home improvement store to buy a plant. This might seem extreme, but nothing ruins a beautiful cocktail or dessert like a sad sprig of grocery store mint.

- What is the best way to store this garnish to help preserve freshness before the shoot? This is especially important for fresh produce items. It's good to know if they hold up better refrigerated or at room temperature. Cilantro, for example, keeps longer if you put the cut ends in a glass of water (like flowers in a vase), and then place a plastic bag over the top and store it in the refrigerator. This will keep your cilantro fresh for up to a week. Simply do an internet search of "how to keep (fill in the blank) fresh" for the garnish you're going to be using to get tips on keeping it fresh.

- Do I need to have anything else on hand to help keep the garnish looking great? For example, avocado slices are best when tossed with lemon juice to prevent oxidation. Lemon wedges need a little bit of juice added to them last minute as they will start to dry out and lose their juicy appearance.

- Do I need to practice preparing this garnish? This is especially important when it comes to cocktail styling. Practicing things like citrus twists or cucumber ribbons ahead of time is important. These can also be great reasons to collaborate with stylists, chefs and bartenders who are intimately acquainted with ingredients and their proper preparation.

+ CHALLENGE

Pick three or more of your most frequently used garnishes for the food you typically photograph, and do the research outlined in the questions listed in this lesson. Take notes about the things you've learned. Is there an opportunity to plan and prepare better for future shoots? Is it something you should start growing at home to have it always fresh on hand? Set your garnish game up for success, and deepen your knowledge of your go-to ingredients.

+ Basil, dill, cilantro and parsley

41. MAKING SANDWICHES, BURGERS AND
FOODS BETWEEN THE BREAD LOOK BEAUTIFUL

Sandwiches are one of the hardest foods to style and capture. This includes burgers, sliders and anything composed between sliced bread or buns. If you are hired to capture sandwiches, it's worth bringing in a food stylist if you're not well-versed in sandwich styling. Beautiful sandwiches don't generally happen on accident and take a good bit of practice to perfect.

Over the years, I have honed my sandwich-styling skills owing to a personal obsession with eating them. I also love a challenge. These are my top tried-and-true tips for working with sandwiches:

- The bread can make or break your image. This might sound dramatic, but I'm serious. A bun or bread that is too big or too small, awkwardly shaped, a distracting color, too shiny or too flat can pull focus from the overall sandwich. Consider how much filling will be on your sandwich and what will visually complement the components. For example, for the burger on the opposite page, I wanted the meat and toppings to be the first place the eyes were drawn. So, I selected a bun that was of moderate size compared to the size of the beef patty and had a little bit of shine and golden plumpness. When in doubt, I find that brioche buns photograph nicely and work well with a variety of sandwich types. A thick multigrain and seed bread is my go-to for more standard sandwiches. I like to select a bread that isn't sliced so that I can determine the thickness of the slices. I also like to toast buns and breads for sandwiches to add a hint of color and texture.

- Think about color. We discussed the importance of color in the previous chapters, and these concepts apply to the filling of sandwiches. There are so many options for layers, so be intentional when selecting your ingredients. Think through things like the color of the buns, tomatoes, onions, spreads and sauces and any other various components that come in different colors and how those choices will suit the mood you intend for the image. The pickled red onion on the burger to the right sends the message of a Southwest-style dish and adds a lively pop of pink that is set off in contrast with the green surface, lettuce, guacamole and jalapeños.

- Bring reinforcements. Like we discussed in Lesson #37 (page 105), every sandwich I photograph has makeup wedges, T-pins and toothpicks hiding somewhere inside. I use the wedges to prop up layers inside the sandwich if ingredients are uneven or if the sandwich needs to be made more level. T-pins are helpful to nail down things like avocado slices, tomatoes and lettuce. Toothpicks are a quick-and-easy way to stabilize the overall structure. Ensuring that your sandwich is stable will help prevent unintended shifts in ingredients.

- Start over. I am pretty sure that every sandwich or burger I've built took at least a few attempts at some of the layers. It's not unusual to start placing ingredients only to find that they aren't sitting quite right. Instead of fighting with something that isn't working, I find it can be easier to start over again. Don't take this as defeat or failure, but instead an important part of the process.

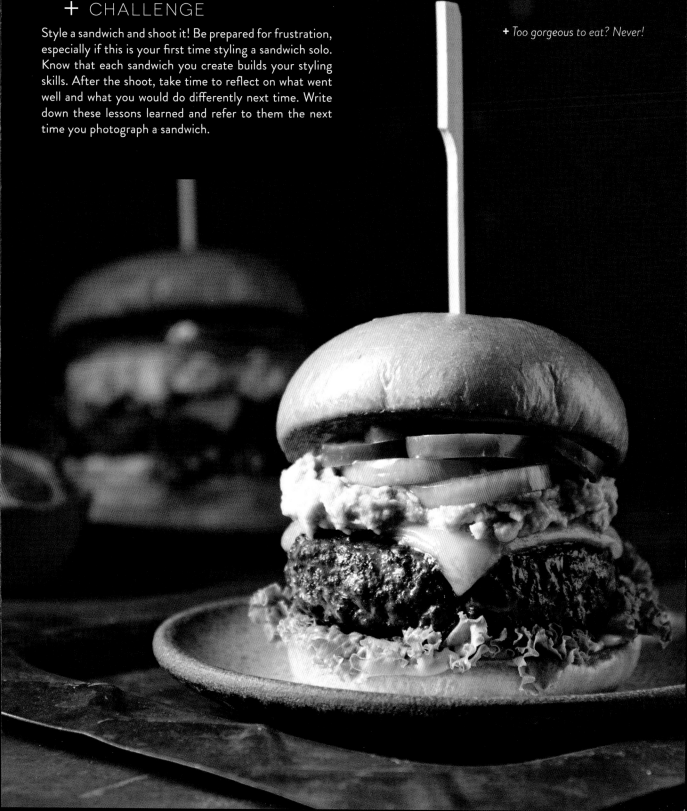

+ CHALLENGE

Style a sandwich and shoot it! Be prepared for frustration, especially if this is your first time styling a sandwich solo. Know that each sandwich you create builds your styling skills. After the shoot, take time to reflect on what went well and what you would do differently next time. Write down these lessons learned and refer to them the next time you photograph a sandwich.

+ *Too gorgeous to eat? Never!*

42. STYLING TIPS
FOR SENSATIONAL SALADS

In preparation for writing this book, I polled my students to get their input on the most difficult foods to style and shoot. Consistently, across the board, **people shared that soups and salads are challenging**. That's why I had to devote the next two lessons to these foods. I have always loved shooting both of these things. I find it magical how light can reflect off the surface of soup. I also love creative compositions involving multiple bowls together in one shot. And salad can be full of interesting and colorful ingredients that add visual appeal. However, there are some common mistakes and pitfalls when it comes to capturing soups and salads. Let's begin with salad:

- Start with superfresh ingredients, and store them in a way that maximizes freshness. Avoid wilted greens and oxidized fruits and vegetables. Buy them right before you need them and be choosy when you're at the grocery store. If the stock that's available on the shelves doesn't look fresh, ask someone who works in the produce department if they have fresher items they haven't put on the shelves yet. They might be able to get you something fresher from the back.

- Keep the room where you're shooting chilled. Similar to shooting ice cream (page 134), I like to work in a colder space. So, if you have the ability to crank the air conditioner, it will keep the food looking perky.

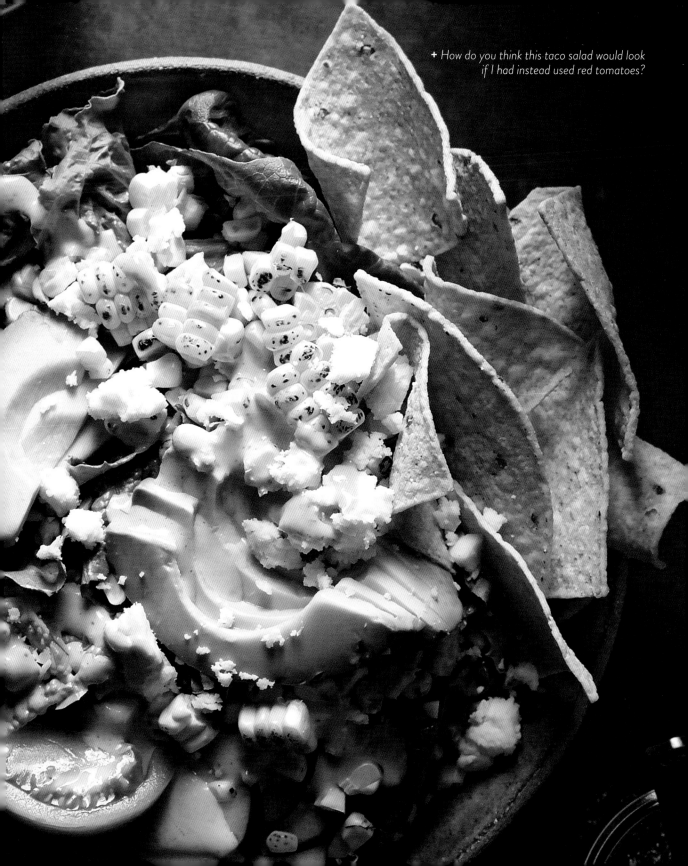

+ How do you think this taco salad would look
if I had instead used red tomatoes?

- Replate the dish as many times as you need. The goal for a salad is something perfectly imperfect, like it softly dropped from the sky onto the plate. This can be hard depending on the kinds of greens you're using. It's helpful to practice placing greens on a plate and arranging them. Utilize makeup wedges when needed to provide extra lift and separation between leaves. Leaves with more structure, like the romaine on the previous page, can be easier to work with and also have great texture.

- Hone your knife skills. For example, if you have diced peppers on a salad, it will look best if the pepper pieces are all a consistent size and shape. And for avocados, they look best when sliced lengthwise in consistently sized slices. Practicing your knife skills is one of the best things you can do to improve your food styling. If you're not sure where to start when it comes to knife skills, seek out a mentorship from a local chef or check out online culinary lessons.

- Go easy on the dressing. It can add a lot of shine and visual interest to a salad, but in the right quantities. I tend to underdress salad for photos so that it gets the shine from the oil, but the greens don't get weighed down and soggy. For vinaigrettes and lighter-colored dressings, especially when working with more delicate leaves, I will apply the dressing only to the visible leaves with a paintbrush to prevent the salad from wilting. For creamy dressings like ranch or blue cheese, I think they look better drizzled in a zigzag pattern over the top so they can stand out and be seen. In all cases, the dressing is always added last to help keep the salad looking fresh.

- To toss or not to toss? Different salads and stories call for different presentations. Something like a Caesar salad is almost always seen tossed, whereas a salad Niçoise makes more sense with the individual components of the salad arranged neatly. You might consider serving the salad in a large bowl family style or plated on several smaller salad plates as if it's being served alongside a bread basket and drinks.

Before assembling your salad, it's just as important to assess the story of the image and what's most important to communicate visually. An elegant beet salad in a white tablecloth restaurant will be styled differently compared to my festive corn and avocado salad. Think about adding visual cues too that indicate the process of making the salad when appropriate. For example, my corn and avocado salad includes a chipotle ranch dressing. The jar of chipotle peppers is a nod to the flavors that go into the recipe. Understanding the objective of your image and its story will help clarify your creative choices when you dive into plating your greens.

+ CHALLENGE

Plan, prepare and shoot a salad. Think through the presentation, the colors, the story and how to keep it looking fresh. As always, keep in mind what is the most important thing about that salad. How can you set your scene and style your food to support that most important element? After the shoot, record the lessons you learned in your notes so that you can improve the next time you style a salad.

43. SERVING UP STUNNING SOUPS

Soup poses unique challenges in the world of food photography because it involves liquid. Some soups are soupier than others, but **whenever liquid is involved, special precautions and considerations are recommended**. These are my top tips when shooting soup:

- Select the right bowl for the job. Thinking about color and texture is always important, but when it comes to soup, size is also key. I personally like to opt for smaller bowls than I would in real life. When the bowl is too big, the focal point gets lost, and the food has a bit of a boring, monotonous look to it. The only exception is when I'm working with a soup that has a lot of components that need to be arranged, like ramen or pho. It's nice to be able to see the broth, the noodles and the arrangement of the different toppings. I often select several different bowls and test them out before choosing the best one for the shot.

- Fill the bowl to the right height. Each bowl and soup will be different, but my general advice for how high to fill a bowl is for the soup to come up high enough that the light will be able to catch it but not so high that it looks overfilled. If the level of soup is too low, the light can't reach into the bowl and your subject—the soup—will be in shadow. But don't take it too high because the bowl becomes a frame for the soup. Allowing some of the edge of the bowl to be visible helps to support the overall composition and focus the viewer's eye on the star of the shot.

- Chunky vs. smooth. If it's smooth, consider adding a garnish to add visual interest. Things like cracked pepper, a drizzle of oil, pepper flakes or herbs can jazz up a tomato soup or a pumpkin bisque. Chunky soups, on the other hand, are all about showcasing the ingredients in the soup and making sure they are visible. My go-to method for chunky soups is to fill the bowl with the larger components first, and then add the appropriate level of liquid. If I'm plating a stew, I'll use a slotted spoon to pull out the vegetables and meat first and add that to the bowl. I will build them up in the bowl so that when the liquid is added, the ingredients are readily visible. I have also seen some stylists add a false bottom like a smaller bowl or makeup sponges, and then pour the soup over top to help boost ingredients. This works particularly well if the bowl is larger and requires a lot of soup to fill it.

- Manage and take advantage of reflections. My favorite part about soup is having fun with reflections. As we talked about in Finding the Sparkle for Images That Look Luscious (see Lesson #9 on page 36), specular highlights unlock our salivary glands and give the visual clues that something is delicious. Liquid creates a shiny, reflective surface, so soup is a prime candidate to capitalize on specular highlights. The trick is to keep them in check. If you set up your shot and the whole surface of the soup is a highlight, adjust your camera to a higher or lower angle. You will see how that affects the highlights for the worse or better. Also, particularly if there is texture to your soup, rotate it around to see how that impacts the highlights. Magic happens when you have the right amount of sparkle on your soup.

- Serve the soup at room temperature. A lot of soups, if served hot, will change as they cool. Creamy soups can start to separate. Thinner soups can start to evaporate and leave lines around the edge of the bowl. Also, heat radiating out of your soup can impact the garnish. Cilantro added to a bowl of hot tortilla soup won't stay fresh for long. Room temperature to cold food is much more stable and will look better for longer.

- Use a funnel to top off the liquid in your bowl. One of the biggest frustrations with soup is that it sloshes around when it's moved, and then leaves a ring around the sides of the bowl. Sure, you can wipe around the edges and clean it up, but I prefer to avoid the issue altogether. I fill the bowl of soup off set, but not as high as I want it to be in the final image. Then I place the soup in the scene and use a funnel to top off the soup so that it rises above any sloshing that happened when the bowl was transferred. The funnel helps to avoid splashing on set. Then, if I need to move the bowl, I do so very, very carefully, but also have superabsorbent paper towels handy for any cleanup.

+ CHALLENGE

Have a favorite soup? Time to shoot it! Experiment with the soup in different bowls, taking test shots and seeing which one suits your soup best. Share your favorite shot online, and remember to tag #pictureperfectfood. Did you learn something new as you were shooting your soup? Take notes to cement what you learned.

+ *Tortilla soup*

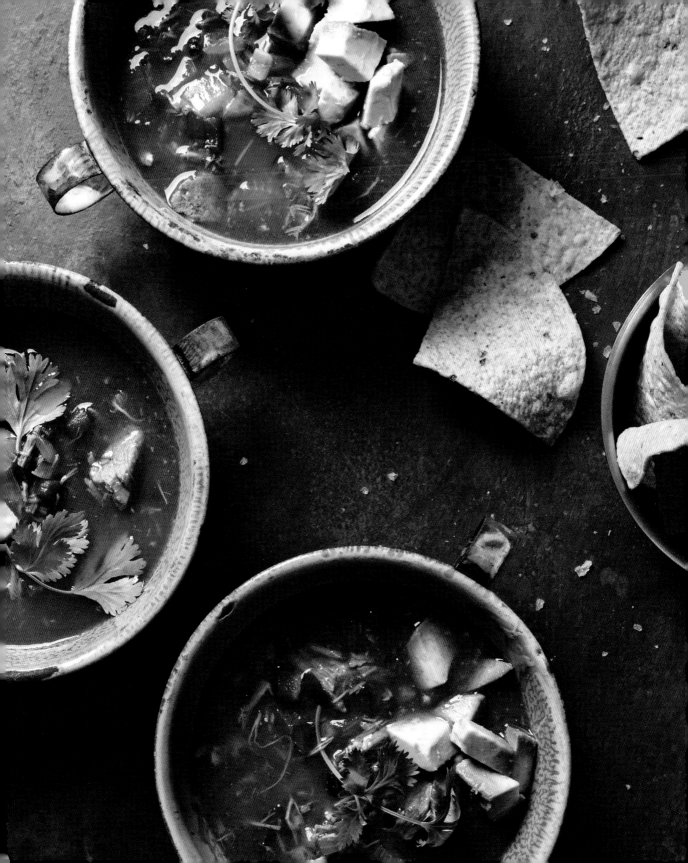

44. HOW TO MAKE FLAT FOODS
LOOK FABULOUS

Whenever I get asked, "What's your least favorite thing to photograph?" I always say, without hesitation, "Quesadillas." Seriously, they're the worst. My archnemesis. But it's not just quesadillas that are difficult. **It's the larger category of flat foods that can frustrate food photographers.** From pita to empanadas, crepes to quesadillas, I have some tried-and-true strategies that can help make flat foods more photogenic:

- Never has there been a better reason to have a stunt double for your food. It can be difficult to visualize the best angle and composition for flat foods. For example, if you're shooting crepes, you might think they'll look best folded into triangles and stacked one on top of the next in a row. But perhaps, once you get it into the scene, it doesn't look right and the angles feel awkward. That's an opportunity to experiment with different configurations, different ways of folding the crepes and finding the position that works best. I always have a lot of test shots for flat foods.

- Choose the best angle. There is no universal perfect angle for capturing flat foods. However, I do always keep in mind that it's important to see the shape of the overall food as well as what's inside it. Like empanadas and hand pies, you can see their shape and form from overhead, but to see the filling, you might need to break them open and view them from a three-quarter angle. You will need to assess what will be best for the particular dish you're shooting. I like to do a lot of image research before diving into a flat food shoot and see what angles other photographers have successfully used before. I have a Pinterest board filled with images of flat foods shot from a variety of angles to use as inspiration.

- Show some of the filling. For the flat foods with fillings like quesadillas, calzones and arepas, as mentioned, slicing into them can help make the filling visible. Additionally, I sometimes add a little bit of extra filling spilling out where the opening is so that the flavor profile is obvious. I don't want to turn the plate into a sloppy mess, but adding a visual cue helps the viewer know what's inside.

+ *Notice how the shadows are cast downward, which helps define the edge of each of the slices.*

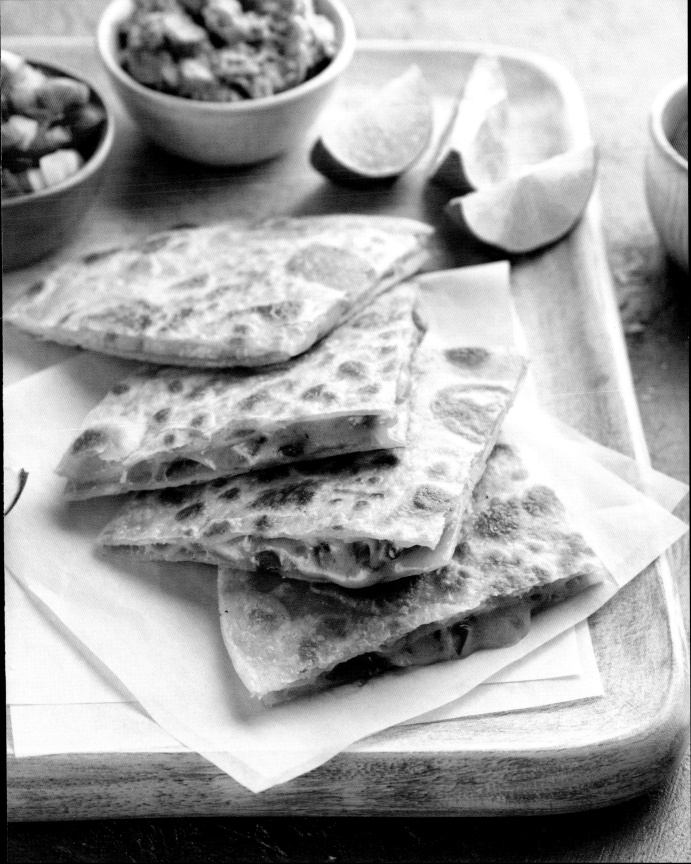

- Add condiments and garnish. Many flat foods also lack color and visual interest. Their one-note, flat, brown exteriors can benefit from the addition of colorful accompaniments. I love to add fresh cilantro, limes, pickled onions and hot sauce to scenes of quesadillas. Calzones can become more interesting with the addition of herbs, a ramekin of marinara sauce and grated parmesan cheese. Think about the condiments that would naturally pair with the dish and incorporate more color and textures whenever possible.

- Create visual separation. This is the trickiest part, but to me, it is the key to mastering flat foods or items in multiples placed in close proximity. I like the way quesadillas look when they're cut into triangle shapes and layered over one another in line. Placing the cut sides on top of other slices allows the fillings to be visible and creates visual variety and separation. I also think a lot about the direction of the light. If some shadow can be cast in the direction of where the slices overlap one another, that will help the viewer's eyes to see the individual pieces as opposed to one, large, flat item. If you study the image on the previous page, you can see the shadows are casting downward, toward the camera, helping to define the edge of each of the slices.

+ CHALLENGE

Now it's your turn to tackle flat foods. Is there a flat food that has caused you trouble in the past? Perhaps it's quesadillas, hand pies, dosa, pita or crepes. It's time to face that foe again. You can do it! I promise. And if at first you don't succeed, try again. The foods you fear are the ones that can teach you the most. Take notes and incorporate the lessons learned and in time you will be a flat-foods master.

45. CRAFTING BEAUTIFUL BEVERAGES

I consider beverage photography an entirely different discipline from food photography. It's an arena that includes its own unique skills and knowledge. But, certainly, as a food photographer, I have my own favorite tricks for making beverages look thirst-quenching:

- Make the drink glow. Liquid presents a perfect opportunity to shine light from behind the glass, creating a glowing drink. This creates a sense of energy and makes the subject stand out. For this reason, I will often shoot drinks backlit, just like the salty margaritas on page 127.

- Select glassware that suits the drink and the scene. I always research the proper glassware for a particular drink before setting to the task of styling. I especially enjoy glassware that has a little bit of detail and interest to keep things exciting, but is also simple enough to keep the focus on the drink and the garnish. However, don't feel like you have to go the traditional route with glassware. You can get creative and use something nontraditional if it fits with the story you're telling.

- Clean your glassware and handle with care. I always take the extra time to fully wash glasses with soap and water before using them to remove any water spots or fingerprints. I dry them with a lint-free microfiber towel to get them sparkling, and then handle them with a towel or wear gloves to avoid adding fingerprints during styling.

- Tweak the drink to look like it does in real life. Sometimes drinks don't look the same on camera as they do in person and require some modifications to look more realistic. Red wine is a classic example. If you pour a glass of red wine, even when the lighting is perfect, it will look dark and sometimes even black. I typically dilute red wine in order to get the red hue to come across. The amount of dilution depends on the particular wine, so experiment with plenty of test shots until you've achieved the right look.

- Accessorize the scene with props, ingredients and garnishes. I have a lot of drinks props in my collection, including shakers, cocktail spoons, jiggers, cocktail picks, an etched glass cocktail pitcher, strainers, straws and a citrus reamer. Adding these accents to a scene can help bring the viewer into the process of making the drink. Also think about accompaniments and garnishes and how they're prepared. In the margarita on page 127, the glass rims were salted, so the dish of salt in the background fits with the story.

- Drink responsibly. An art director once recommended adding a second drink to an image because, after all, we don't want our viewer to be drinking alone.

Above all, the most important advice I can give when it comes to shooting beverages, just like in the food arena, is to understand that **the best way to present drinks visually is to educate yourself about the beverage world.** There are a vast number of amazing resources to learn about cocktails, mixology and drinks. I have found some of the greatest information in this realm by collaborating with talented local bartenders. I don't drink alcohol, but I love spending time with beverage experts who are excited to share their knowledge about spirits, glassware, purveyors, garnishes and preparation methods. I once had a twenty-minute conversation with a local bar owner about his attention to detail in terms of the quality and clarity of his ice. That sent me down a rabbit hole of researching and learning more about ice and freezing methods. After all, if you're serving someone a top shelf whisky, you don't want to add a cloudy, kitchen tap water ice cube to it.

Perhaps you're sensing a trend, but I firmly believe that great food and beverage photographers are the product of connections with other people who are experts in their own unique disciplines. That's why I hope you take the challenge for this lesson seriously. If you're shy or introverted, it might be an especially hard challenge for you. But also remember that the larger the challenge you tackle, the greater the personal payoff. Don't do the challenges in this book because I told you to. Do them for you and for your own growth. The more you invest in yourself, the better your work will become.

+ CHALLENGE

Connect with a local bartender or beverage expert, and offer to collaborate on some photos. Your local chapter of a bartender's association or your favorite cocktail bar can be great places to start. A lot of bars and bartenders are looking to expand their social media reach and love to have their work photographed. You can offer to take the photos in exchange for learning about their craft and watching them work. It's a surefire way to make a friend, pick up some new knowledge and practice capturing drinks. After the shoot, think about what went well, what you learned and what you can do better next time. Were there unforeseen issues? Unique challenges? Take notes and look at every challenge as an opportunity to expand your skills.

+ *These margaritas were made with nugget ice to add texture.*

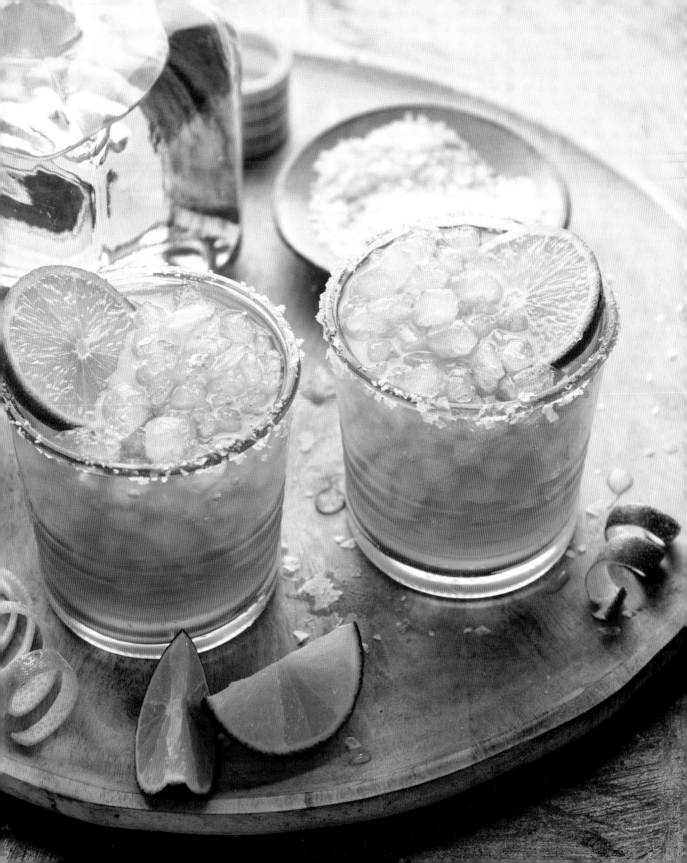

46. TACTICS TO MAKE MEATS
LOOK TANTALIZING

Beef, chicken, pork, lamb and seafood require special treatment and an added level of attention to detail. They also generally involve more expensive ingredients, so it's best to approach them with adequate forethought. It doesn't get much worse than botching an expensive steak. Here are a few things I keep in mind any time I'm shooting meat:

- Know your audience. When planning a shoot, particularly one with beef, be sure you're clear on who the audience is for that image and how they like their steak prepared. If you're working with a client, they will generally dictate the "doneness" of the meat. But bear in mind that just because you think medium rare is the best way to eat a steak, chances are the audience will prefer the visual of a medium steak. Thinking through the proper cooking temperatures for the desired look of the meat, particularly if it's being sliced, is important. The ribeye pictured here was cooked to 130°F (54°C) for the medium-rare reddish-pink inside.

- Consult your butcher on the cut and any prep it needs. If you're shopping for meat, don't settle on what's in the refrigerated case at the supermarket. Talk to the butcher. Not only will they have knowledge to share, but they might also be able to get you a fresher or better-quality cut. Also, they can take on the additional preparations of trimming fat and silverskin if you don't want to do that yourself.

- Use a meat thermometer. Don't leave the cooking temperature to chance. The numbers in cooking meat don't lie.

+ Ribeye cooked to medium rare and sprinkled with coarse salt

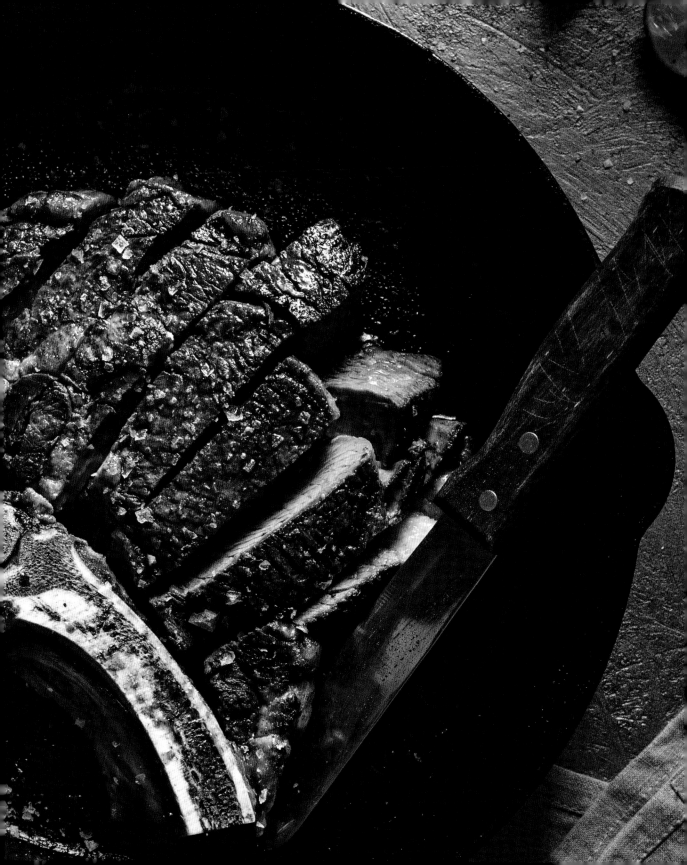

- Prepare it, and let it come to room temperature entirely. If you've ever sliced into a steak fresh off the grill, you'll know that the color changes rapidly. It goes from a lovely, soft, glimmering pink to a matte red quickly. To avoid this, prepare the steak to the desired temperature, and then let it rest at room temperature for a good long time, at least 30 to 40 minutes. I've even been known to prepare a steak the night before a shoot, and then store it in the fridge submerged in vegetable oil overnight. If you cut into the steak once it's fully cooled or even cold, it will still look done on the inside, but the color won't change as rapidly.

- Reserve the juices. As you're resting the meat, collect any juices left behind on the plate. These are the best for adding moisture back into the meat once you've sliced into it. You can brush on oil to add more shine, but the juices of the actual meat have a slightly different quality and can make the meat sparkle like it's freshly sliced.

- Have a backup. If you're shooting one steak, have at least another one or two ready for backup. Things can go wrong even when you're fully prepared.

+ PRO TIP

Fortunately, when it comes to mock meats, cooking temperatures aren't important. Depending on the particular item you're working with, you might want to undercook it so that it retains a plump and fresh look. Things like portobello mushrooms and sausages can start to shrivel up if they're cooked too long. Also, think about the color and how you can roast, brown or sear something to give it some visual interest and make it look extra appetizing.

+ CHALLENGE

Time to tackle a meat of your choosing and photograph it. Of course, vegetarians, if you're certain you'll never shoot meat, feel free to go with a mock meat or mushrooms. Regardless of what you choose to shoot, follow the bullet points, and do your research to fully prep for your shoot. After the shoot, take notes on what went well and what caused issues. Did you need a tool you don't have? Would you have prepared something differently? What was something that made the shoot easier that you will do again in the future?

47. THE RECIPE FOR PERFECT PANCAKES
(AND SYRUP!)

If you have never captured pancakes, they are unbelievably satisfying to photograph. They're loaded with nostalgia and have worldwide appeal. From silver dollars to gigantic flapjacks studded with chocolate chips, pancakes come in many forms and styles. Perhaps it seems odd to highlight this food so specifically, but it's a dish that comes up in shot lists from clients frequently. If you haven't done it already, shooting pancakes is definitely in your future.

Before I tackle a stack of pancakes for a client, I ask a lot of questions to make sure I know exactly what they want. I have found that different people have different opinions about the way pancakes should look. Here are some of the characteristics of pancakes to think through prior to shooting:

· The amount and pattern of browning on the top

· The color and height of the rise on the sides of the pancake

· The number of pancakes in the stack

· The size of the pancakes

· The shape of the pancakes

· The uniformity or differences between each of the individual pancakes

· Butter or no butter

· Fruit or no fruit

· The placement of the maple syrup pour

· The amount of maple syrup on the plate and the amount on the stack

· The color of the syrup: light golden or dark rich brown

The only major "gotcha" when it comes to pancakes is the syrup. Standard maple syrup immediately soaks into the pancakes and doesn't give you a lot of time to adjust your shot once the syrup is poured. Popular viral videos online suggest using motor oil, but that honestly doesn't fare much better.

Instead, taking advice from food stylists I know, I've crafted my favorite syrup recipe. **Using maple syrup and corn syrup heated to the right temperature, you end up with a syrup that pours, but once it hits the pancakes, it drips into place and holds its form.** This syrup mix will hold for hours, giving you plenty of time to make final adjustments to your lighting and camera angle. I have also provided my Picture Perfect Pancakes recipe. It's my go-to whenever I need to shoot pancakes and the recipe I used for the shot you see on page 133.

+ CHALLENGE

Capture your ultimate stack of pancakes. Dress them up how you like, light them the way that feels right for you and your story. Think about the composition, including elements like coffee, additional plates, syrup pitchers and silverware. Infuse all of the lessons you have learned thus far to create a stellar stack, and as always, take notes about what you learn in the process.

PICTURE PERFECT
PANCAKES RECIPE

These pancakes make for pretty pictures!

YIELD: 16 (3-INCH [8-CM]) PANCAKES

INGREDIENTS

2 cups (250 g) all-purpose flour

2 tsp (9 g) baking powder

1 tsp baking soda

¼ tsp salt (optional)

1 tbsp (15 ml) white vinegar

1½ cups (360 ml) whole milk

2 large eggs

METHOD

Heat an electric griddle or a nonstick skillet over medium heat while you make the batter. In a medium bowl, combine the flour, baking powder, baking soda and salt (if you plan to eat the pancakes, salt makes them tastier). Set aside. In a small bowl, add the vinegar, milk and eggs. Whisk to thoroughly combine. Slowly add the wet ingredients to the dry ingredients, whisking while you pour, to create a smooth batter. It's okay for it to be slightly lumpy. The batter should be slightly thick but still pourable. If it's too thick, add in a couple tablespoons of additional milk to thin the batter.

Once the griddle is heated, use a measuring cup or a large scoop to pour the batter on the griddle to form a pancake. (Using a scoop or a measuring cup ensures that your pancakes will be uniform in size.) Allow the batter to cook, and watch the surface of the pancakes. Once small bubbles form across the surface of the pancake, flip it carefully to cook the other side. When you do this flip, you'll be able to see how much or how little the bottom was cooked and get

a better sense of how long it should cook on each side. You want the pancake surface to be golden brown. Allow the flipped pancake to cook for another minute, and then transfer it to a wire cooling rack to cool. Continue to cook the pancakes until you've used all the batter, perfecting your timing and flipping techniques through the whole batch. Practice makes perfect pancakes!

PICTURE PERFECT
MAPLE SYRUP

To get the syrup just right, invest in a candy thermometer.

INGREDIENTS

½ cup (120 ml) pure grade-A maple syrup

2 tbsp (30 ml) light corn syrup

METHOD

In a small saucepan, combine the maple syrup and corn syrup. Place on the stovetop over medium-high heat. Do not stir as that will introduce undesirable bubbles to your final syrup. Allow the syrup to come up to a rolling boil, and then allow it to cook for approximately 10 minutes. Use a candy thermometer to monitor the temperature. When the syrup reaches 240°F (116°C), remove the saucepan from the heat and transfer the syrup to a heatproof measuring cup by slowly pouring it from the saucepan into the cup. You will notice that the syrup is slightly thickened.

Once the syrup is in the cup, it will still have a lot of foamy bubbles on top. This is normal, and they will dissipate as the syrup cools. Once the bubbles have dissipated, and the syrup is clear again, you are ready to pour it on the pancakes or waffles. If you are not ready to use the syrup as soon as it's ready, you will want to keep the syrup warm so that it doesn't harden before you pour it. If it does get a bit too thick after sitting a little too long, you can microwave it for 30 seconds to warm it up, making it pourable again.

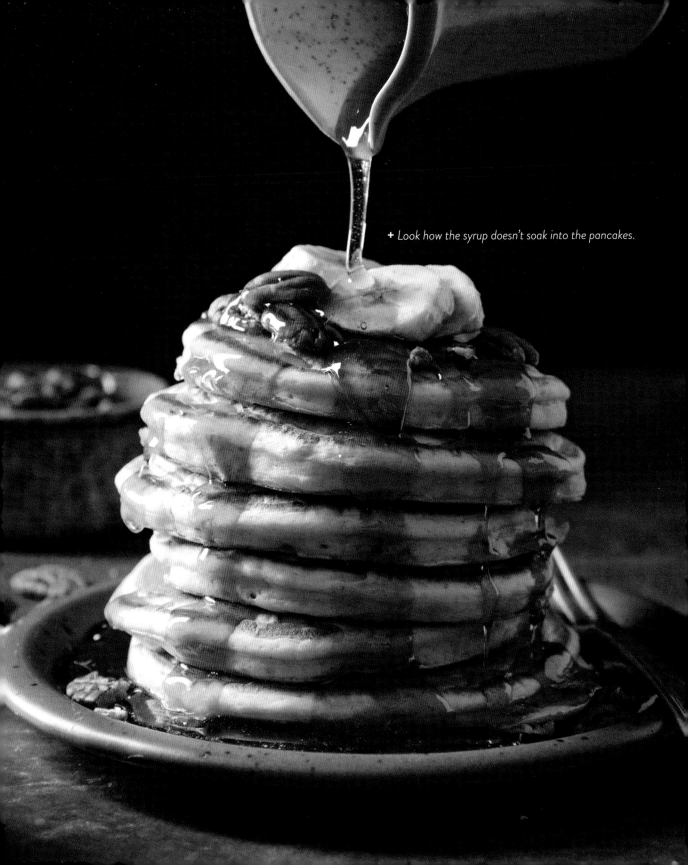

+ *Look how the syrup doesn't soak into the pancakes.*

48. HOW TO KEEP YOUR COOL
WHEN SHOOTING FOOD THAT'S FROZEN

Did you know there are food stylists whose sole focus and specialty is working with ice cream and frozen food? It's a fine art to keep frozen food looking perfect for the camera. Whenever I share images of ice cream, sorbets and popsicles I always get asked, "Is that real?" Commercial photographers and food stylists were once known for using fake ice cream, particularly before digital photography, because of the amount of time it took to get the shot. Today, with the speed of production, the ability to review images instantly and the magic of postproduction, more often than not, the food is real. Certainly, there are situations where mashed potatoes are used in place of ice cream, but that is becoming less the norm.

That said, frozen foods require particular preparations and precautions above and beyond the use of a stunt double. Before you set up your next shoot with frozen food, keep these tips in mind:

- Follow a two-step freeze process. When working with things like ice cream that need to be prepared prior to shooting, an excellent strategy is to create your scoops, and then freeze them thoroughly before introducing them to the set. Allowing the scooped ice cream additional time to freeze will help slow the melting process on set. I like to create my scoops the night before the shoot, place them on a parchment-lined baking sheet and then freeze them so they're ready the next day.

- Set your freezer to the right temperature. Obviously, a freezer is required to keep the food frozen. Dedicated ice cream photographers and stylists are known to have multiple freezers at different temperatures to get the perfect scoop. The first freezer will be at 0°F (-18°C), which makes for ice cream that's frozen but still soft enough to be scooped. Then, they will have a second freezer at -20°F (-29°C) that will hold the scooped ice cream to make sure it's rock solid frozen before placing it on set. This isn't going to be possible for most home food photographers, and I find as long as you're working quickly, a 0°F (-18°C) freezer is plenty cold to get the scoop you need and for it to hold long enough to get the shot.

- Make sure you have a lot of extras. As a general rule in food photography, expect the unexpected. With that in mind, it's always good to have multiples of the food you're shooting, especially when working with frozen items, so that if you need to reset the scene, you have a ready hero waiting in the freezer.

- Crank the air conditioning in the room. If you can set your thermostat lower than normal a few hours before your shoot, it will help ensure that the temperature in the room isn't working against you.

- The higher the fat content of the ice cream or treat, the faster it will melt. When I have the option, I will select low-fat ice cream so that I have more time before the melt factor sets in.

- Have freeze spray for touch ups. If you hop online and search "freeze spray," you'll find this helpful tool for handling touch ups when melting does start on set. It won't extend the life of your ice cream a ton, but it can help hold back drips while you shoot a couple of extra frames.

+ CHALLENGE

Time to tackle the dreaded frozen foods! Nothing gets my heart racing more than knowing I have frozen food on set. It's great practice and will also force you to double down on shoot preparation and planning your shots. Frozen food photographers will tell you that 99 percent of the work happens before the ice cream is placed in front of the camera. After the shoot, open up your notebook and see all the notes you have accumulated in the previous challenges. Give yourself a pat on the back for tackling so many tough subjects!

Each food is unique, so in addition to taking notes about what you learned in this shoot, continue to add to your lessons learned with each new food you shoot moving forward. Imagine yourself five years from now having styled and captured hundreds of different foods. You will be unstoppable.

+ *I cranked the air conditioner in my studio before shooting these chocolate-dipped dragon fruit and coconut popsicles.*

FINDING INSPIRATION

Continuing the Journey and Encouraging Your Creativity

+

Every photographer has good days and bad days. I can't tell you how many times I have set up to shoot something and felt like I was out of ideas. Shelves full of props, recipes on demand, options galore, and yet the creative well runs dry. This is totally normal and a natural part of the creative experience. Instead of beating yourself up, which artists are apt to do, run through one of the following exercises. And, most importantly, give yourself time and space, because inspiration will always return if you're patient. I promise.

49. USING MUSIC
TO INFLUENCE
YOUR IMAGES

I always create better pictures when I'm having fun and in a good mood. Nothing improves my mood more immediately than music. But what I also find interesting is how **different types of music can influence the outcome of an image.** Have you ever seen music? Approximately 4 percent of the population regularly experiences synesthesia. It's described as the experience of seeing colors in connection with different musical notes or keys. This is a very overt connection of music to the visual world, and it isn't everyone's experience. But I do believe in the subconscious power of music and that if you close your eyes and listen to a song, it will paint pictures in your mind.

Close your eyes. Imagine hearing classical piano music. What colors and pictures come to mind? Imagine hearing '70s rock, loud heavy metal, bubblegum pop. What visions, tones, feelings and colors enter your thoughts? How do those pictures change the longer you listen? Imagine how a picture of roast chicken might look different when inspired and styled listening to a '90s boy band vs. Beethoven.

Any guesses what I was listening to while I styled and shot this charcuterie plate? I find that if I need inspiration, my favorite tunes can get me revved up and excited to shoot again.

+ *Paul Simon's song "Kodachrome" inspired me to paint a canvas for the background of this image and to capture the lyrics, "those nice bright colors" and "all the world's a sunny day."*

+ CHALLENGE

Start compiling your photography playlists. I have a few different playlists I use, and I'm constantly adding new songs that pump me up or get me inspired. It's also helpful to have these playlists if you are ever shooting with other people. I have a photographer who I assist from time to time, and he has the best old-school rap playlists that make a long shoot day a lot of fun.

50. THE POWER OF COLLABORATING
WITH OTHER CREATIVES

Some of my greatest moments of growth as a food photographer have come as a result of working with other creatives. Food photographers, food stylists, props stylists, art directors, publishers, creative directors, photo editors, chefs, bartenders, restaurateurs, bloggers, influencers, farmers, artists and artisans all have their own unique experiences and views of the world that they bring to their work. **Working together can engage synergy.** No one person knows everything, so collaborating creates an environment where skills and insights can be shared.

I also find the accountability of having another person involved in a project can help, particularly when a project is large and overwhelming. Everything's better with a friend. But friends and colleagues who share your love of food photography don't just show up out of thin air. Meeting new people requires intention. That is your challenge. Make friends. Below, I have listed places where I have met amazing people and encourage you to do the same. Not only for the sake of building your skills but for the amazing experiences and knowledge you can share with them.

Places to meet friends in food photography:

· Photography and blogging conferences

· Online blogger and creator groups

· Trade shows for food products and businesses

· Your local restaurant association

· Farmers' markets

· Craft shows

· Workshops

· While assisting on photoshoots or when featuring creatives in your own content

And my best, number-one top recommendation is to reach out directly and connect with people whose work you admire. Propose a project to collaborate on. Some photographers and stylists might be busy, so they might say no, but then again, they might also say yes! And is hearing no the worst thing ever? Any successful person will tell you that their achievements came as a result of hearing a lot of noes on the road to some very big, important yeses.

+ CHALLENGE

Get out there and make some friends! After all, like anything, a certain amount of success has a lot to do with who you know. If this challenge makes you nervous or if you're a shy person, give yourself a due date for this task. Any time I have to do something that I don't enjoy or am afraid to do, I turn it into a game. For example, when I have to cold call potential clients, I set a time to do it and don't allow myself to do any photography until I have completed the task.

51. EXPLORING THE ART WORLD
TO UNCOVER NEW IDEAS

I studied art history in college, and while I was exposed to a lot of different styles of art, I especially loved fauvism. Les Fauves were a group of modern artists known for their use of bold, expressive colors and simplified design. Do you see it in my work? That little bold current that runs through what I create?

As much as I love being a part of creative communities on social media, food images online can start to look very similar, replicating current trends and popular styles. I think it's good to be familiar with trends, but I also like to draw inspiration from other places. I find that an afternoon in a museum or an art history book can expose me to different ideas for lighting, contrast, composition, layering, styling, shapes, lines and color combinations.

For example, looking at modern architecture, you might be inspired to incorporate some unique angles and shapes into an image. Perusing illuminated manuscripts from the Middle Ages can provide new inspiration for props selection, textures and colors. Wassily Kandinsky's famous "Squares with Concentric Circles" inspired a creative garnish and perspective on the Negroni on the next page.

I consider these art history sessions to be exercises in building my visual library. Our brains are filled with the imagery we've been exposed to over our lifetime, and being able to pull from this creative repository provides more reference points for when we're behind the camera.

+ CHALLENGE

Pick up an art history book that focuses on a specific movement or even one that covers a larger general span of time like Western culture or the history of Asian art. Take note of work that captivates you or you find interesting. What is it that makes the work unique? What could you take from that work and incorporate into your photography? Don't stop at one book, though. And don't just stop with painting. Sculpture, architecture, portrait photography . . . all art inspires. As a student of photography, you are a student of the greater art community, and you owe it to your creative mind to expand your artistic literacy.

In case you need a little extra inspiration, these movements and artists are some of my favorites:

· Mannerism: El Greco and Jacopo Carucci

· Baroque: Caravaggio and Artemisia Gentileschi

· Impressionism: Paul Cézanne, Mary Cassatt and Henri Matisse

· Abstract art: Wassily Kandinsky

· Mexican muralism: Diego Rivera and Aurora Reyes Flores

· Pop art: Andy Warhol and Yayoi Kusama

· Neo-expressionism: Jean-Michel Basquiat

A cocktail for Wassily Kandinsky

52. THE SECRET NO ONE TELLS YOU
ABOUT PHOTOGRAPHY

I have saved the most important lesson for last. There is no challenge for this one . . . simply advice. It's a statement that has propelled me through many moments of self-doubt in my work. Because, I'm sorry to say, and perhaps I should have mentioned this earlier, that in any creative endeavor you pursue, especially when you are first getting started, you will experience disappointment. You will look at the work of other people and compare yourself. You will look at your work and lament that it's not good enough. You might want to quit. I have been there and still have moments where I feel like my work doesn't measure up.

You will see the work of others and wonder, "What am I missing? What's their secret?"

Ryan, my husband, told me this decades ago, and I stand by it: There is no secret.

There is no hidden mystery or secret knowledge. If you see someone doing something remarkable and want to know how they've done it, simply ask. You might be surprised how generous people are with what they know when you ask. On the other hand, they might not tell you, but chances are, other people know what they know, too, and someone will be happy to share. There is nothing new under the sun and no knowledge so deep that you can't figure it out. There is no secret moment, no greatest artist of all time, no winner of the Best Photo Ever Contest. There is no secret password that suddenly unlocks all of your creative potential and awards you the "I've Made It" certificate.

Don't give up because you think "real photographers" possess an unattainable secret power reserved only for a privileged few. Please, call yourself a photographer and be wildly generous with the things you know. The world will be better for it. Stop worrying about uncovering a secret that doesn't exist. Instead, get behind your camera, do your best, enjoy the process, make a lot of mistakes, learn, grow, make friends and keep showing up. The rest will take care of itself.

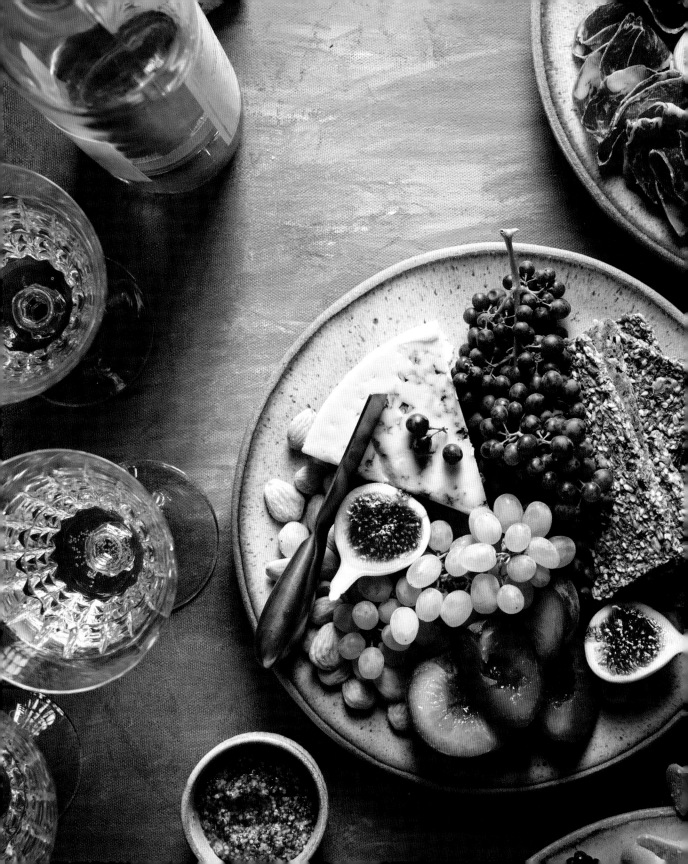

+ *Cheers to you, my friend!*

+ ACKNOWLEDGMENTS

I would like to thank the online community of food photographers who have supported my content and educational offerings. You have inspired me to become a better food photographer and to dig deeper into this craft. This book would not exist without you and your excitement for what I do.

Thank you to the amazing team at Page Street Publishing for bringing this book to life. I am forever grateful for your expertise and encouragement through the book-writing and photography processes. It has been an honor to partner with you, and I'm so proud of what we created together.

Thank you to my family and friends for being the best cheerleaders throughout the book-writing process. Your enthusiasm and positive energy is infused into the words I wrote and the images I captured here and will undoubtedly have an impact on those who read this work.

Thank you to my boys for being fantastic hand models and for your honest feedback about the images. I'm glad we reshot the peanut butter and honey pictures, too.

And finally, thank you to my husband, Ryan, who believes in me more than I believe in myself. I am forever grateful for your unconditional love and continual encouragement and for not allowing me to talk myself out of writing this book. I could not do any of this without you.

+ ABOUT THE AUTHOR

Joanie Simon is a commercial photographer based in Phoenix, Arizona. She specializes in food photography and styling, working with top brands to create craveable images for marketing campaigns, packaging and digital media. Joanie is best known for her popular educational platform The Bite Shot, where she teaches students around the world how to improve their food photography through video tutorials. Her educational work has been featured by professional industry outlets including Fstoppers, Peta-Pixel, Food Blogger Pro and Shutterstock, and she has collaborated with photography brands including Canon, Datacolor, PhotoShelter and B&H. When she's not shooting, Joanie is spending time with her husband, two boys and their miniature Australian shepherd, Bruce.

+ INDEX